GRAPHIC WORKS OF
Max Klinger

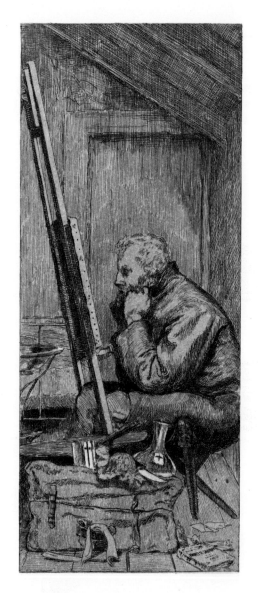

The Artist in the Garret

GRAPHIC WORKS OF
Max Klinger

Introduction, Notes and Bibliography by

J. KIRK T. VARNEDOE

Department of Art History, Columbia University

With ELIZABETH STREICHER

Foreword by DOROTHEA CARUS

Technical Note by ELIZABETH SAHLING

Dover Publications, Inc., New York

Published in Canada by General Publishing Company, Ltd., 30 Lesmill Road, Don Mills, Toronto, Ontario.
Published in the United Kingdom by Constable and Company, Ltd., 10 Orange Street, London WC2H 7EG.

Graphic Works of Max Klinger is a new work, first published by Dover Publications, Inc., in 1977.

International Standard Book Number: 0-486-23437-1
Library of Congress Catalog Card Number: 76-26380

Manufactured in the United States of America
Dover Publications, Inc.
180 Varick Street
New York, N.Y. 10014

Foreword

by Dorothea Carus

Following the Max Klinger exhibition of 1970 in Leipzig, the first
major presentation of the artist's work since the 1920s, the 1971
exhibition of Max Klinger's graphic oeuvre arranged by Jan van
Adlmann for the Wichita Museum was a noteworthy project.
For the first time in over sixty years, Klinger's work was given
a comprehensive exhibition in America. This show and the
subsequent ones at Berkeley and Cambridge opened up new
perspectives relative to Klinger's art. Attention now focused on
Klinger's modernity, his inventive iconography and staggering
technical prowess. Also, the awareness of the impact Klinger's
imagery had on such major artists of the twentieth century as
Munch, De Chirico, Dali, Ernst and Kollwitz led to a reevaluation
of the artist's place in the history of modern art. And when there
followed, in 1974, an exhibition in New York of the etchings and
drawings of Klinger's most famous series, the *Glove* cycle of
1878/81, requests mounted for an interpretation of the artist's
graphics, as well as information on his life and work. It was then,
in direct response to these demands and inquiries, that this book
was conceived. It is the first publication on Klinger's graphics in
English and the first publication in any language to attempt a
modern evaluation and interpretation of the complex phenome-
non that Klinger's graphic art presents.

All the art has been photographed directly from original
impressions in the Carus Gallery, New York, the only exceptions
being the first two plates and the reference figures in the Intro-
duction.

Klinger was the modern artist par excellence. Modern not
in the sense that is currently given to the word, but in the sense
of a man of awareness who feels the heritage of centuries of
art and thought, who sees clearly into the past, into the present
and into himself.

<div align="right">GIORGIO DE CHIRICO, 1920</div>

List of Plates

Frontispiece: The Artist in the Garret (late 1870s)

ETCHED SKETCHES (RADIERTE SKIZZEN), 1879
1. The Beginning of Spring (Frühlingsanfang)
2. Dying Wanderer (Sterbender Wanderer)

RESCUES OF OVIDIAN VICTIMS (RETTUNGEN OVIDISCHER OPFER), 1879
3. Painterly Dedication / Invocation (Malerische Zueignung / Anrufung)
4. First Intermezzo (Erstes Intermezzo)

EVE AND THE FUTURE (EVA UND DIE ZUKUNFT),1880; COMPLETE CYCLE
5. Eve (Eva)
6. First Future (Erste Zukunft)
7. The Serpent (Die Schlange)
8. Second Future (Zweite Zukunft)
9. Adam
10. Third Future (Dritte Zukunft)

INTERMEZZOS (INTERMEZZI), 1881
11. Pursued Centaur (Verfolgter Centaur)

12. Battling Centaurs (Kämpfende Centauren)
13. Simplicius at the Hermit's Grave (Simplicius am Grabe des Einsiedlers)
14. Fallen Rider (Gefallener Reiter)
15. Cupid, Death and the Beyond (Amor, Tod und Jenseits)

CUPID AND PSYCHE (AMOR UND PSYCHE), 1880
16. Psyche on the Cliff (Psyche auf dem Felsen)
17. Psyche with the Lamp (Psyche mit der Lampe)

A GLOVE (EIN HANDSCHUH), 1881; COMPLETE CYCLE
18. Place (Ort)
19. Action (Handlung)
20. Yearnings (Wünsche)
21. Rescue (Rettung)
22. Triumph
23. Homage (Huldigung)
24. Anxieties (Ängste)
25. Repose (Ruhe)
26. Abduction (Entführung)
27. Cupid (Amor)

FOUR LANDSCAPES (VIER LANDSCHAFTEN), 1883
28. The Road (Die Chaussee)

A LIFE (EIN LEBEN), 1884
29. Dreams (Träume)
30. Seduction (Verführung)
31. Abandoned (Verlassen)
32. For All (Für Alle)
33. Into the Gutter! (In die Gosse!)
34. Caught (Gefesselt)
35. Going Under (Untergang)
36. Suffer! (Leide!)
37. Back into Nothingness (Ins Nichts zurück)

DRAMAS (DRAMEN), 1883
38. In Flagranti

ON DEATH, PART II (VOM TODE ZWEITER TEIL),
1898–1909

Introduction

by J. Kirk T. Varnedoe, with Elizabeth Streicher

In April of 1878, the Art Union in Berlin showed a suite of ten ink drawings, entitled collectively *A Glove*, by the 21-year-old artist Max Klinger (see Plates 18–27 and Figs. 1 and 2). With that exhibition, and with the work he showed later in the same year at the Annual Art Exhibition, Klinger leapt into critical prominence. The merits and meanings of his debut works were disputed, but even those who were displeased acknowledged that there was something unmistakably original and compelling about this artist's vision, already in full force despite his youth. Klinger had begun at the Art School in Karlsruhe only four years before, at 17, and had followed his first teacher, Karl von Gussow, to the Berlin Academy in 1875. This rapid rise to fame was, moreover, to be only the beginning of a long and immensely successful career. Klinger's reputation and influence eventually extended well beyond Germany's borders, and he came to be hailed as a modern Renaissance genius for his work in painting, sculpture and graphics.

In his diverse and prolific production, however, Klinger's initial love and the source of his 1878 success, graphic work, remained a special, independent mode of expression for him. Beginning with etched editions of drawings conceived in the 1870s, including *A Glove*, Klinger went on to produce a body of prints (14 major cycles, comprising 265 plates)* that is as

*The only cycles not represented here are the *Festschrift des Kgl. Kunstgewerbe-Museums zu Berlin*, an early work, and *Das Zelt*, Klinger's last cycle (see postscript at conclusion of Notes on the Plates).

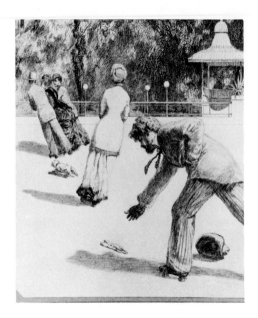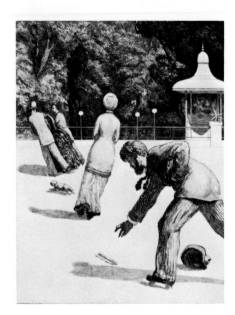

ambitious and complex as his work in other media, and that, indeed, has proved to be of more enduring import and appeal. Looking, for example, at *A Glove* (of which the first etched edition appeared in 1881), one finds that its impact has not simply endured, but become more forceful still; these images seem not only original, but uncannily modern. By contrast, Klinger's giant allegorical paintings and elaborately polychromed sculptures now evoke a more distant, historical interest—a situation perhaps explicable in terms of Klinger's attitude toward these media.

As Klinger explained in his essay *Malerei und Zeichnung* (Painting and Drawing), he felt that works in color—and this might be taken to include his tinted sculpture as well as his paintings—were best suited to evoke the realm of nature, rendering its forms as the eye experienced them; such works should, he said, be free of distorting factors such as passion and violence, and should be complete in themselves. On the other hand, he felt that drawings (meaning in this context any works in black and white, especially prints) were particularly suited to embody the domain of fantasy and *Weltanschauung,* or one's attitudes about the world; such works could better deal with the sordid or grotesque, both in imagination and in reality, and could be less complete, but more suggestive, in the image they gave the viewer. Perhaps Klinger's paintings and sculptures seem less successful to

1. Klinger's original drawing for "Action" from the cycle *A Glove* (photo by Karlheinz Grünke, Hamburg).

2. The etching "Action" from *A Glove* (Plate 19).

us because his self-imposed limitations kept them suspended in a peculiar incompletion, blending a highly concrete reality of forms with a remote ideal of life as it should be. On the other hand, his fantasy and his trenchant views on society as it was, embodied in the prints, contain a fuller range of emotion and a more personal expressive intensity that speak directly to us.

The themes that the prints treat, for example, are strikingly modern, in two seemingly contradictory respects. On the one hand, Klinger was ahead of his time in the expression of disturbed fantasies about love and death. *A Glove* predates by several years the studies of Freud and Krafft-Ebing on sexual psychoses and fetish obsessions; but, in its bizarre nightmares over a purloined feminine accessory, this story seems to usher into our consciousness a similar vision of human susceptibility to the vagaries of the libido and the imagination. Furthermore, the glove itself seems blatantly Freudian, being simultaneously phallic (in the fingers) and vaginal (in the sheath configuration, and even more specifically in the repeatedly accentuated open slits of its back and palm). The menacing beast (Plate 26) is also phallic, and the preoccupation with water (Plate 24) and penetration (Plate 20) in the dream-images are familiar manifestations of sublimated sexuality. Not only in this specifically psychoanalytic instance, but also in the emotionally charged ways other cycles treat themes of personal anxiety (see especially *A Love*, Plates 46–55, and *On Death, Part I*, Plates 56–65), Klinger's disturbed subjectivity is strikingly evident. In this respect, he seems to provide a link between the earlier nineteenth-century German romantic tradition (whose psychological tenor lies at the base of compositions

3. *Monk by the Sea,* painting by Caspar David Friedrich, 1809 (Staatliche Schlösser und Gärten, Schloss Charlottenburg, Berlin). 42⅞ x 66⅝ in.

4. "Abandoned" from Klinger's cycle *A Life* (Plate 31).

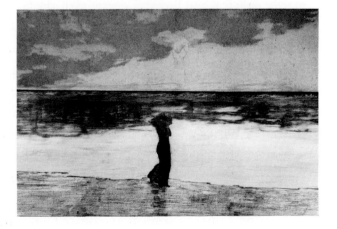

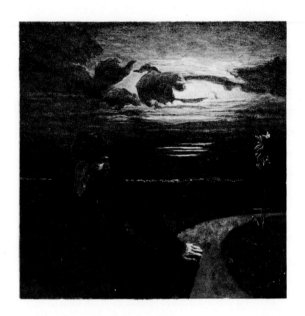 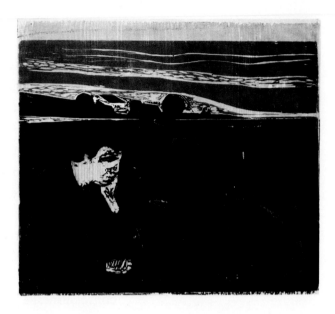

such as "Abandoned," recalling Caspar David Friedrich; see Figs. 3 and 4) and the modern expressionist movement, on which he had a direct influence through the younger Norwegian artist Edvard Munch. Klinger provided not only a direct source for some specific Munch images (compare Figs. 5 and 6), but also an influential precedent for Munch's themes of nightmare and spiritual distress.

On the other hand, and apparently opposing this stress on fantasy and metaphysical anxiety, there runs through several of Klinger's print cycles an equally modern and equally deeply felt concern with reality. Klinger's attention to such societal problems as the plight of women (*A Life*, Plates 29–37, and *A Love*, Plates 46–55), urban violence, and poverty (*A Life* and especially *Dramas*, Plates 38–45) places him in the context of other, primarily political and literary, currents of the late nineteenth century. The social criticism implicit in this aspect of Klinger's work recalls Marx or Darwin (whom we know Klinger read) rather than Freud. It immediately prefigures the writings of politically oriented "gutter realists" like the playwright Gerhart Hauptmann and the work of those early twentieth-century artists concerned with a socially oriented, rather than self-oriented, expressionism. The best case in point is that of the graphic artist Käthe Kollwitz, who greatly admired Klinger and delivered a eulogy at his funeral; her themes of social unrest draw particularly directly on Klinger's *Dramas* (compare Figs. 7 and 8).

5. "Night" from Klinger's cycle *On Death, Part I* (Plate 56).

6. "Evening/ Melancholy/ On the Beach," color woodcut by Edvard Munch, 1896 (Collection, The Museum of Modern Art, New York, Abby Aldrich Rockefeller Fund. 16 15/16 x 20 15/16).

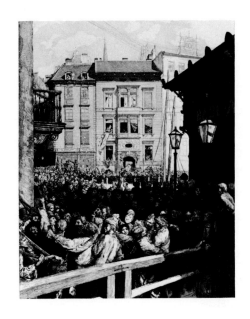 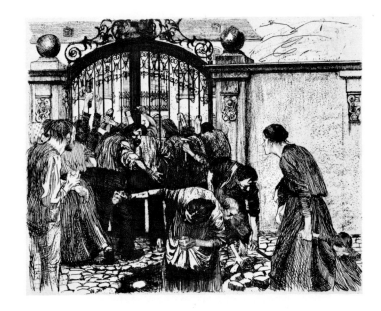

7. "March Days I" from Klinger's cycle *Dramas* (Plate 43).

8. "Riot," etching by Käthe Kollwitz from her cycle *The Weavers,* 1897 (Prints Division, The New York Public Library; Astor, Lenox and Tilden Foundations). 9⅜ x 11⅝ in.

It may seem odd that Klinger's modernity should thus be based on an apparent contradiction: subjectivity and fantasy on the one hand, and social awareness and realism on the other. Yet this dichotomy is central to Klinger's art, and was present from the outset of his career. Beyond his devotion to his teacher Gussow, the leading figure in a French-influenced school of realist genre painters, Klinger also deeply admired the painting of Adolf von Menzel, the father figure of realism in nineteenth-century Germany. In the same years, however, he was studying the grotesque fantasies of Goya, and he moved to Brussels in 1879 specifically to study under Charles-Emile Wauters, a painter of the neomedieval macabre. Similarly, though swept away by admiration for the realist novels of Flaubert and Zola, he remained devoted to the fantasies, often horrific, of early nineteenth-century romantic literature, especially in the work of E. T. A. Hoffmann and Jean Paul.

We can attempt to explain this dichotomy in various ways. It might, for example, be seen as evidence of a personal psychological problem, a combination of hypersensitivity and escapist emotional instability. Or, in a Marxist light, we might find here an archetypal ideological dilemma, between self-indulgent dreaming and the political responsibilities of critical analysis, set in a period of crisis in burgeoning capitalism. However, there is little in Klinger's biography to support such interpretations. Apparently

politically disengaged, he remained devoted to his cultured, well-to-do parents (his father was a soap manufacturer in Leipzig) as he moved from success to success in a life of bourgeois respectability. His modest eccentricities were limited to a certain restlessness—he lived for varying periods in Brussels, Berlin, Paris, Munich and Rome before returning to settle in Leipzig in 1893 —and a virtually lifelong bachelorhood. His first enduring liaison, with Elsa Asenijeff, began when he was 41 and lasted almost 20 years (a child, Désirée, was born out of wedlock in 1900) ; then, in 1919, less than a year before his death at 63, Klinger married another woman, Gertrud Bock, his junior by decades.

Beyond the fact that this biography does not substantiate them, pathological and political explanations of Klinger suffer from another important flaw; tending to picture the artist as being involuntarily in the grips of a conflict he was unable to resolve, they fail to do justice to the willful, self-determined nature of his originality. There is another, potentially more fruitful, way in which to consider Klinger's work. We can see its complexity, both thematic and stylistic, as owing to his conscious confrontation of an aesthetic dilemma affecting numerous European artists of his generation: that of finding a more expressive form of the naturalism of the 1860s and early 1870s. The vast popularity of one style of the time, French impressionism, has overshadowed the significantly different realist styles that appeared concurrently in France, Germany and elsewhere. Dissatisfied with the thematic monotony and emotional passivity of a landscape-based naturalism, many artists throughout Europe formed nonimpressionist or even counterimpressionist styles with the goal of capturing a romanticism of modern life, a vision combining an evocation of the problems of the modern psyche with a quasi-photographic truth to observation. Such a desire for expressive realism, already announced in the literature of the 1860s by writers like Zola and Dostoevsky, may provide the context in which to understand the mixture of objectivity and subjectivity in Klinger's work. It helps to put in the context of a broader revival of romanticism, for example, both Klinger's attention to Goya and E. T. A. Hoffmann, and his readaptation of early nineteenth-century motifs such as Friedrich's. More importantly, this kind of

reevaluation of Klinger's place in his time can help to dispel the issue of irresolution and to focus our attention where it should be focused: on Klinger as an intelligent artist with purposeful goals, and on the sophisticated way in which he controlled his innate talents.

On the technical level, first of all, we should recognize that Klinger was a virtuoso. His earliest prints already show a confident ability to control tonal variety and to translate onto plates the loose, nervous hatching and crisp silhouettes that marked his ink drawings. More importantly, he learned rapidly to orchestrate a plate with a variety of effects, especially in aquatint (see Technical Note), in order to enrich the expressive impact of his images. By playing off smooth washes of aquatint and rougher textures of etched cross-hatching, and by combining these with a judicious sense for the power of spaces left blank, he was able to manipulate extraordinarily the effects of space, movement, light and focus that determined the drama of his scenes. Klinger also had an innovative sense of formal design. The use of linear arabesques in several of his prints (see, for example, Plate 22) prefigures the plant-like abstractions of late nineteenth-century Art Nouveau.

Klinger never, however, flourishes either technical virtuosity or decorative richness solely for its own sake. When we

9. "On the Tracks" from Klinger's cycle *On Death, Part I* (Plate 63).

10. "Madonna," hand-colored lithograph by Edvard Munch, 1895 (courtesy of The Art Institute of Chicago). 23 15/16 x 17 7/16 in.

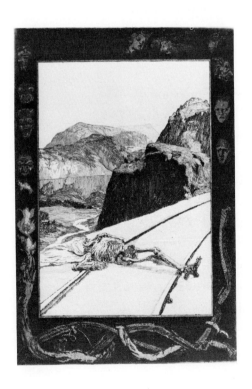

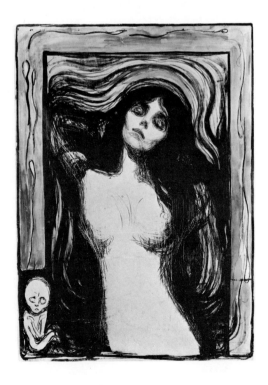

consider, for example, the exceptionally prominent margins he often includes (as in Plate 63), we can see that these are important not only as formal elaborations, but also, and in fact primarily, as devices for increasing the meaning of the plates; they tell a second story, extending the narrative in time or reinforcing the emotion. When Munch adopted this practice of Klinger's in such prints as "Madonna," he was not simply borrowing a form, but taking over a method of augmenting the impact, spiritual *and* visual, of the image (compare Figs. 9 and 10).

Even the basic element of detail in Klinger's images often has a similar, intentionally expressive function. The obsessive piling-up of detail in "In Flagranti" (Plate 38), for example, contributes to the static, frozen quality of the scene, so important as a foil to the terror of the event; and in "First Encounter" (Plate 47), the suffocatingly full vegetation, described to the last leaf, contributes the visual energy, and sense of pregnant fullness, to an otherwise mundane scene. More basically, it is the cool, even banal, detailing of the most fantastic fantasies and violent actions that gives the special quality to so many of Klinger's visions. This selective use of detail finds its complement, in turn, in Klinger's equal sensitivity to the suggestiveness of empty spaces (see especially Plate 28). The whole range of such techniques for expressing meaning without obvious distortion—divided narrative, focus, emptiness—suggests that his graphics might well be described with the vocabulary of photography, and especially cinema.

Frequently, for instance, in the narrative progression of plates within his folios (*Eve and the Future*, Plates 5–10, and *A Love*, Plates 46–55, are good examples), Klinger uses a cinematic "flash-forward" plate to establish a tension of premonition that markedly affects the impact of the following scenes. Furthermore, the drama of movement from one plate to the next is knowingly orchestrated in terms of changes in contrast, texture, size and space. Moving through a Klinger cycle, we are constantly surprised by a restless inventiveness, by shifting balances of different systems of rendering and composition. This richness of invention, giving each plate its separate life, is accompanied by a carefully selective narrative construction, which values economy even at the

 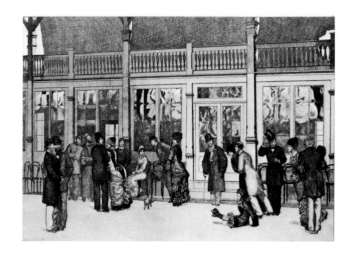

11. Klinger's original drawing for "Place" from the cycle *A Glove* (photo by Karlheinz Grünke, Hamburg).

12. The etching "Place" from *A Glove* (Plate 18).

risk of ambiguity. In the fashion of early films (and of certain sophisticated contemporary cinema as well), his most successful cycles dwell on a reduced number of significant moments between which the viewer's imagination must provide the linking continuity. The laconic titles, factual but not explanatory (see for example *A Glove* and *Dramas*), reinforce the premonition of silent film.

Cinematic techniques can be seen within individual plates as well. Klinger's careful choice of moment, for example, accounts for much of the power of scenes such as "Place" (Plate 18), "Action" (Plate 19), "Abduction" (Plate 26) and "In Flagranti" (Plate 38). These are not simple snapshot visions; in them, Klinger gains a special impact by combining in one apparently momentary scene a set of conflicting gauges of time's pace. If we compare the drawings for "Place" and "Action" with the prints (Figs. 1 and 2, 11 and 12) we can see this subtle manipulation of time at work. In the drawing for "Place" the small child sits crying after her fall; in the print, by arresting her fall at the moment of impact, Klinger fractures the unity of the otherwise static scene with a jarring note of instantaneity. In "Action," he similarly plays off motion against stasis. The extremely subtle changes in proportion and interval he effects between the drawing and the print serve to emphasize the oppositions, by stressing the invisible central axis that divides the reaching hand from the glove, and by emphasizing the cut of the matching horizontal division of the terrace edge. In the etching, the foreground figure is thus more

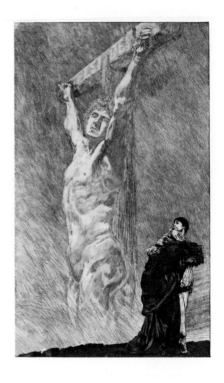 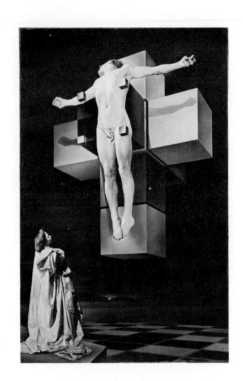

clearly isolated in a spaceless lower quadrant. All movement is then
conceived in opposing diagonals set against this rigid right-angle
geometry of the starkly sun-bleached terrace. The stately, gliding
sway of the other skaters establishes a pace that is at odds with the
frantic scurry of the dog and the lunge of the man (Klinger
himself), whose hat, just fallen, punctuates the impetuosity of the
thrust-in-progress. The scene will not settle into one time sense,
and stays suspended, simultaneously urgent and endlessly slow, like
some eerie *déjà-vu* experience in our mind's eye.

Klinger's directorial talent is such that scenes of apparent
banal documentation, such as "Action," take on the haunting
quality of a dream, while scenes of unbelievable fantasy, such as
"Abduction" (Plate 26), strike us with a disturbingly credible,
even hallucinatory immediacy. Particularly in these highly specific
dream-images, we see the artist stretching the devices of realism to
include states of heart and mind that the following generation felt
required more thoroughgoing distortions and greater distance
from visual reality. In this regard, Klinger links most directly not
to the expressionists, or to film, but most especially to the sur-
realists. He shares with surrealists like Dali the concept of the
waking dream: the heightened expressiveness of a psychic dis-

13. "Suffer!" from Klinger's
cycle *A Life* (Plate 36).

14. *Crucifixion,* painting by
Salvador Dali, 1954 (The Metro-
politan Museum of Art, Gift of
the Chester Dale Collection,
1955). 76½ x 48¾ in.

ruption that remains linked to an obstinately specific mundane reality. Klinger and Dali both juxtapose, for example, images of irreconcilably different scale (Klinger's "Suffer!" and Dali's *Crucifixion*, Figs. 13 and 14); and both depict hallucinatory fantasies within the context of eerily placid and vacant landscapes (see Plates 15 and 65). Klinger's earliest and most direct relation to this strain of twentieth-century imagery, however, was through the forerunner of surrealism, Giorgio de Chirico, who, while a student in Munich, was deeply affected by the art of Klinger, as well as that of Arnold Böcklin. De Chirico admired the *Brahms Fantasies* (Plates 66–70), but was perhaps most influenced by the combination of clear sunlight and dark psyche in prints like "Shame" (Plate 54). In 1920, following Klinger's death, De Chirico published an essay of appreciation that remains the most perceptive analysis of Klinger's relevance to the modern imagination.

De Chirico saw, more clearly than the contemporaries who had praised Klinger as the representative of Hellenic traditions, that there was a unique sense of mystery, antithetical to neo-classical conventions, in this artist's etched visions of antiquity (see, for example, "Invocation," Plate 3, and "Pursued Centaur," Plate 11). For this special vision of the past, as well as for the ability of the prints to extract from modern life "the romantic sense in its strangest and most profound aspects," De Chirico hailed Klinger as "the modern artist par excellence." He described the special *déjà-vu* power of Klinger's vision, and analyzed the "genius" that determined this: "[Klinger's] work, although very fantastic, and rich in images which, for those little acquainted with metaphysical subtlety, might at first seem paradoxical and senseless, is nevertheless always based on a foundation of clear reality, powerfully felt, and never wanders into delirium and obscure ravings."

The basic quality in Klinger's graphic work that seems to have moved De Chirico and the surrealists could be described by the paradoxical phrase "disjunctive unity." We have already touched on this in relation to Klinger's compression of conflicting senses of time into one moment, but it is a more general, fundamental principle in his art, extending from the juxtaposition of banal detail and impossible fantasy within the images and within

15. *Song of Love,* painting by Giorgio de Chirico, 1914 (private collection, New York; photo by Charles Uht). 28¾ x 23½ in.

the cycles, to the thematic dichotomy of fantasy and reality. It is
not, as we suggested before, an involuntary peculiarity of Klinger's
work, but something he actively seeks. Far from being a flaw,
it is his particular success, as he controls this split, holding it in
perpetual poetic tension. Long before the surrealists, he discovered
the emotional power of unresolvable disjunction, particularly
between levels of reality; through this principle, he formulated
another world whose contradictory abnormality had the impact of
real experience. De Chirico's *Song of Love* (Fig. 15) then owes to
Klinger not only the idea of the strange power of the human relic
enshrined (the glove), but also the idea of the indecipherable
mystery that pervades the disjunctive elements of the past and the
present, the extraordinary and the banal, the measurable and the
scaleless, when they are ushered together onto the same well-lit
stage.

Such qualities in Klinger's prints are the core of his origi-
nality and his modernity. But they will not be understood if we
attempt to measure him in the context of, and with the criteria set
by, a view of modern art that sees abstraction as a goal and rep-
resentation as a regression. The dominance of such a limited for-
malist view has for too long relegated Klinger to an unjustified
obscurity. His work must instead be understood in the context of
another sector of modern art, more concerned with the expressive
manipulation of the elements of described visual reality than with
abstract formal values *per se*. It is in this regard that the
perspective of a century, and the experience of surrealism and
film, can allow us to see even more clearly than Klinger's con-
temporaries the ways in which his images work, and to explain
them—up to a point. Beyond that point, however, no facts of his
life nor any explanation of his place within his time, no careful
study of the visual techniques nor comparison with later art, will
fully elucidate the originality that was already unmistakable, and
complete, when his contemporaries first saw *A Glove*. Indeed,
Klinger suggested that, to a degree, this was not completely within
his power to explain, either. He once told his biographer Singer
that his favorite time of day was the very early morning, in the
moments between sleep and waking; at these times, he said, images
came to him, fully formulated, with extraordinary sharpness. We

can understand how his subtle visual sense, and his complete control of the etching medium, gave him the ability to fulfill these experiences in his art, and thus to transport us into a similar realm of privileged suspension. But the best of his images have a kind of finality of form and resonance of meaning that are not only indelibly memorable, but also defiantly inaccessible to explanation by the waking mind.

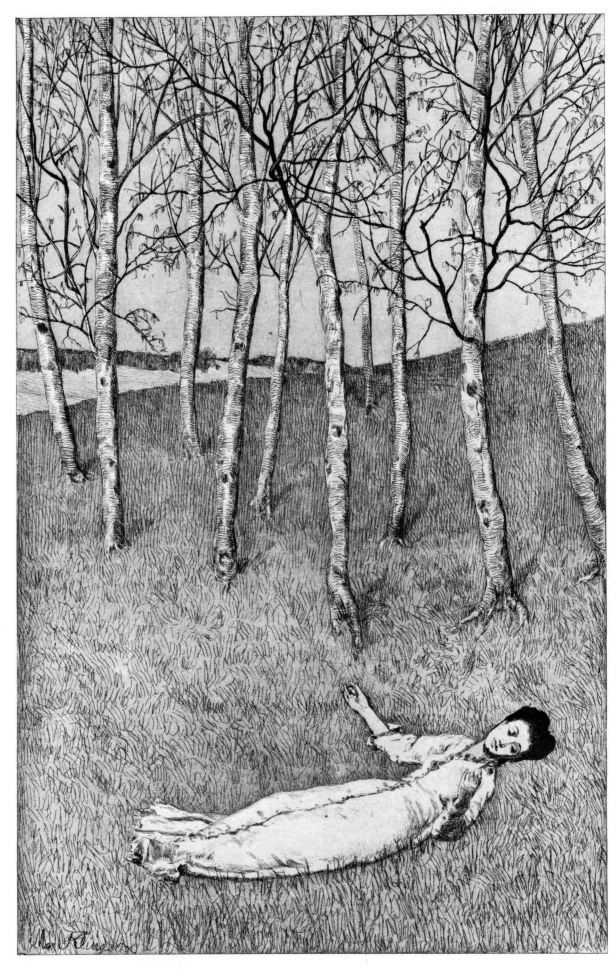

1 Etched Sketches: The Beginning of Spring

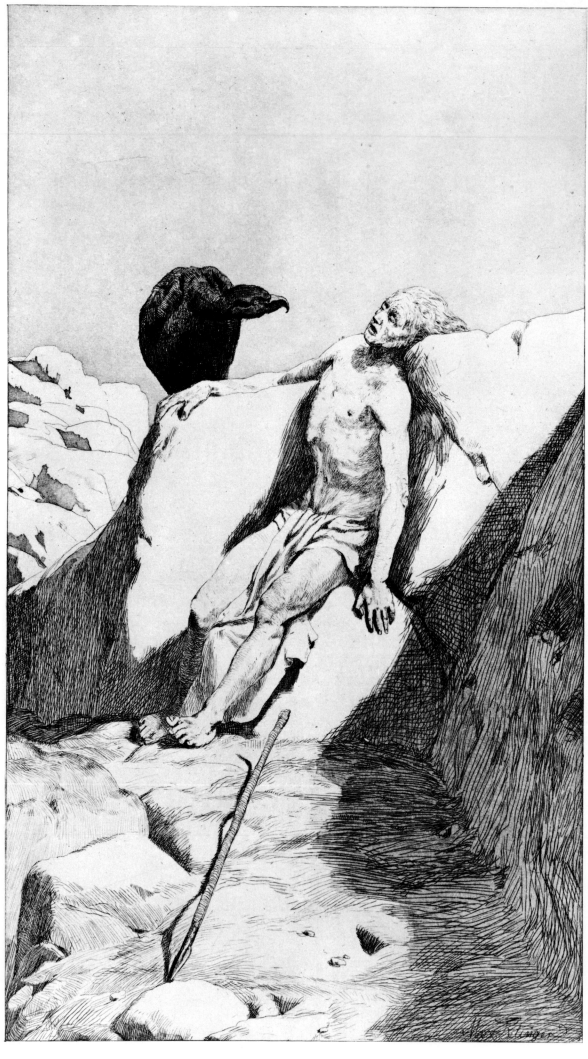

2 Etched Sketches: Dying Wanderer

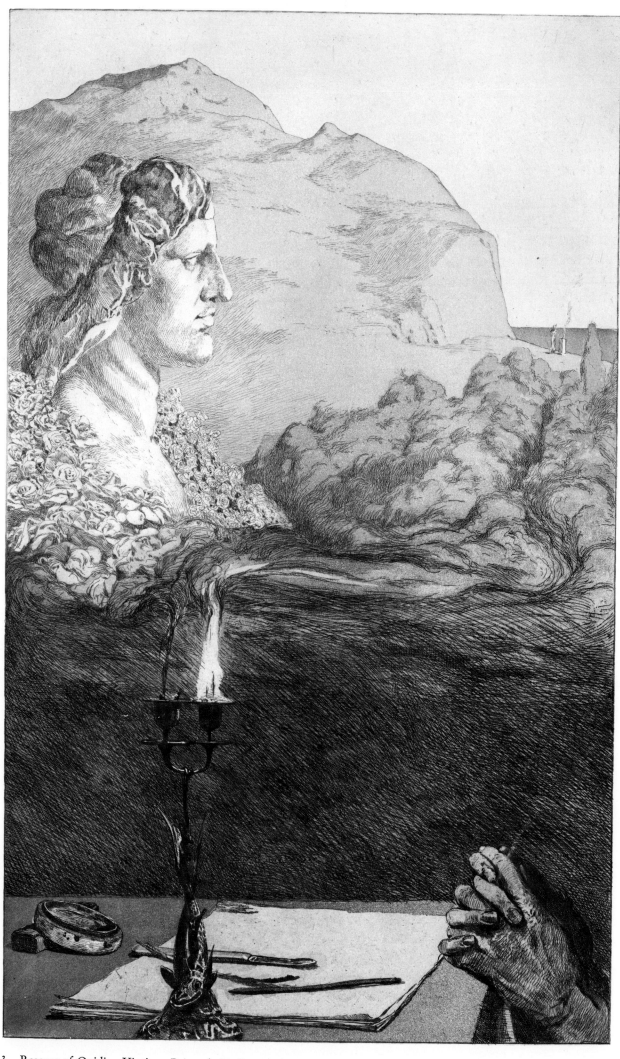

3 Rescues of Ovidian Victims: Painterly Dedication/ Invocation

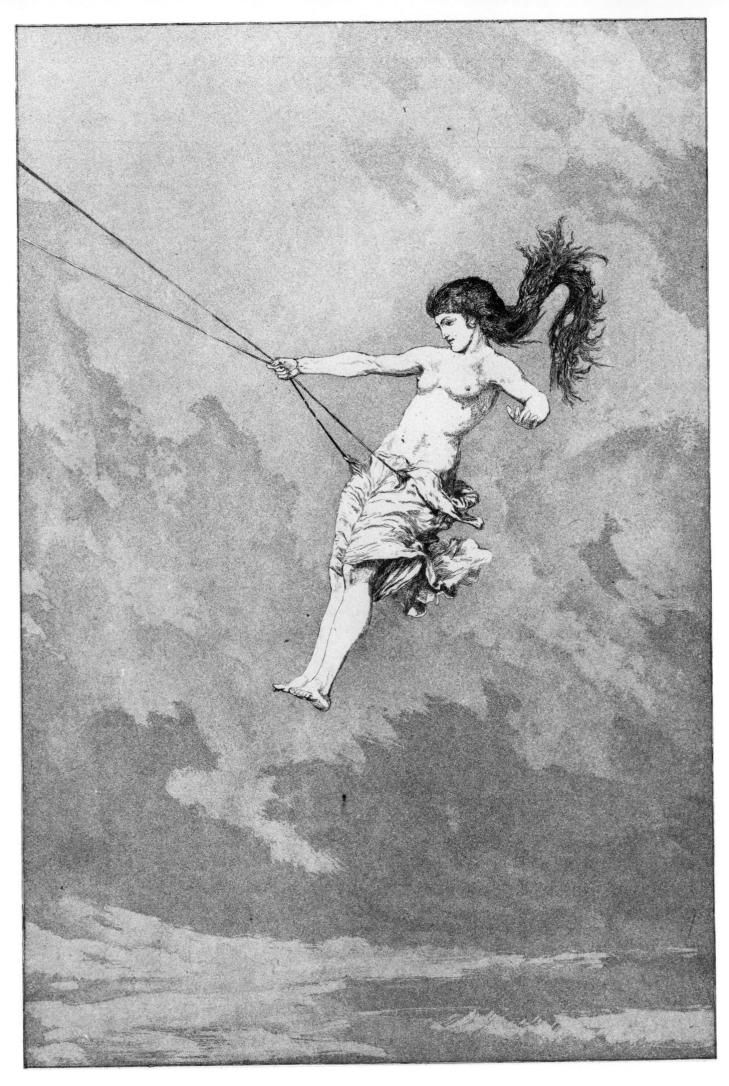

4 Rescues of Ovidian Victims: First Intermezzo

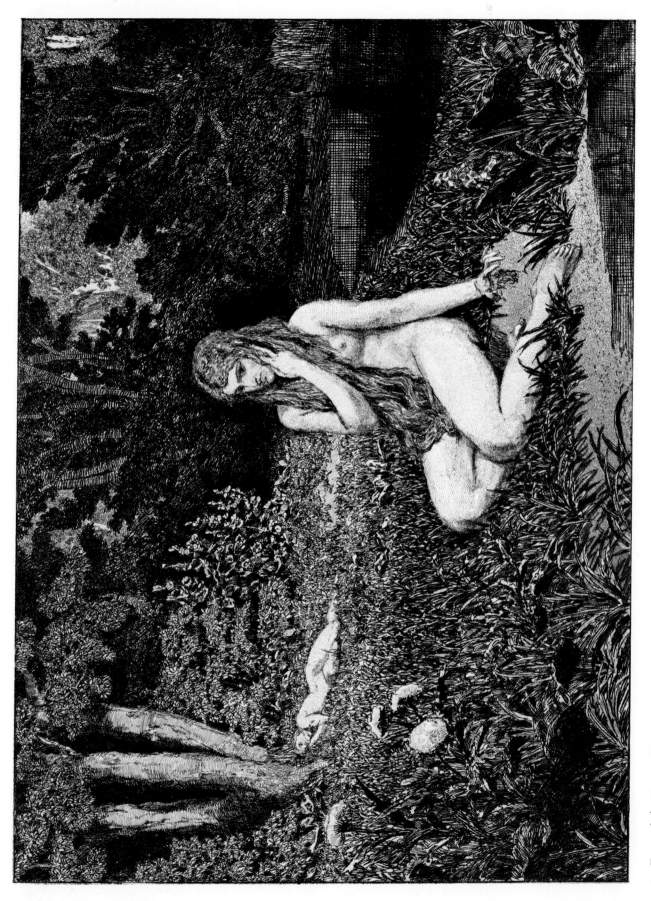

5 Eve and the Future: Eve

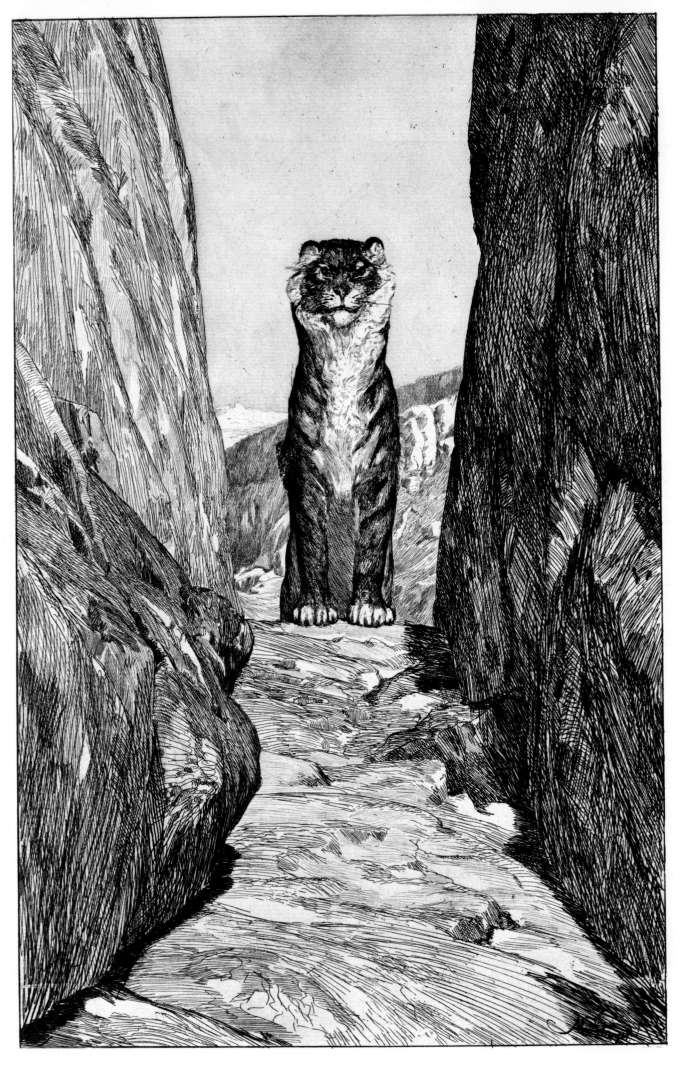

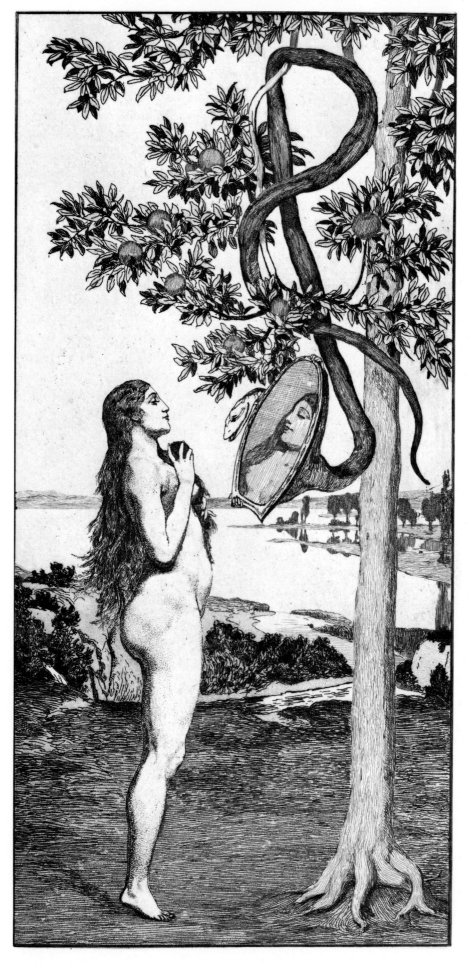

7 Eve and the Future: The Serpent

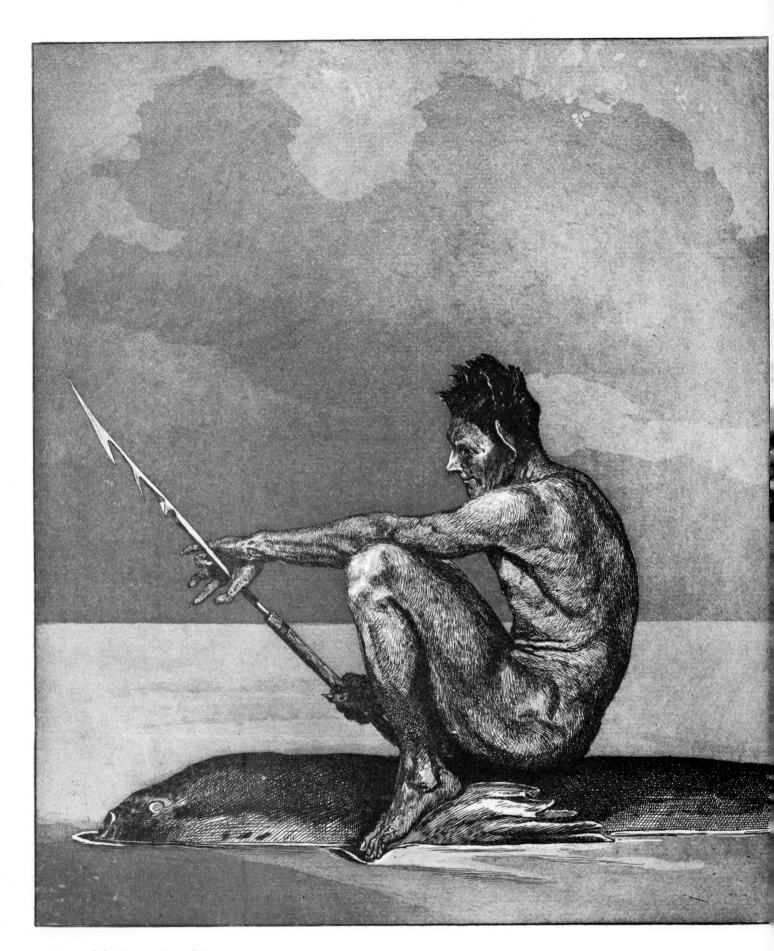

8 Eve and the Future: Second Future

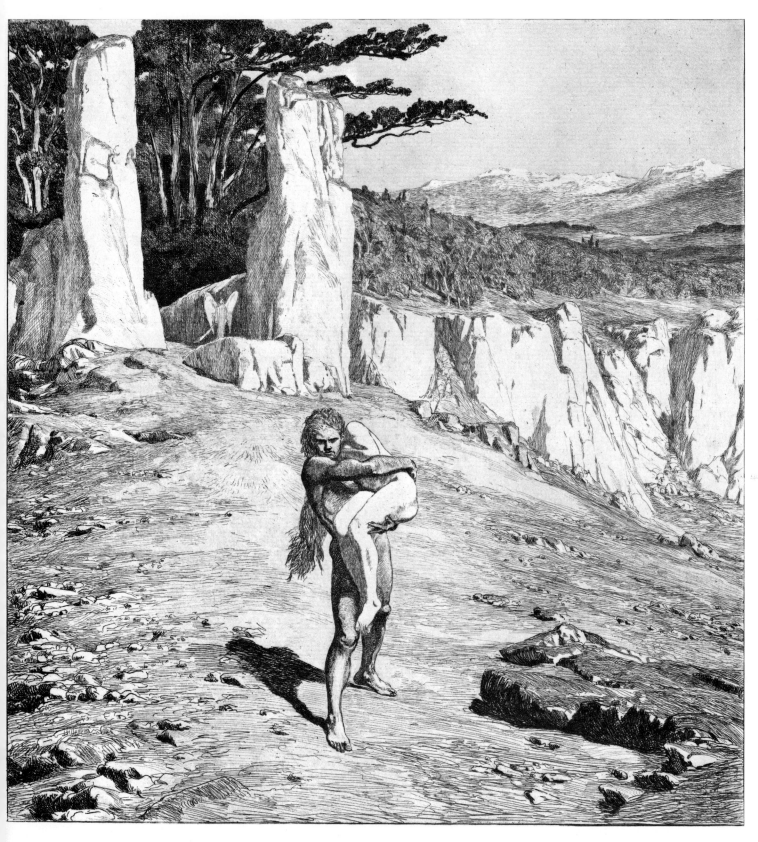

9 Eve and the Future: Adam

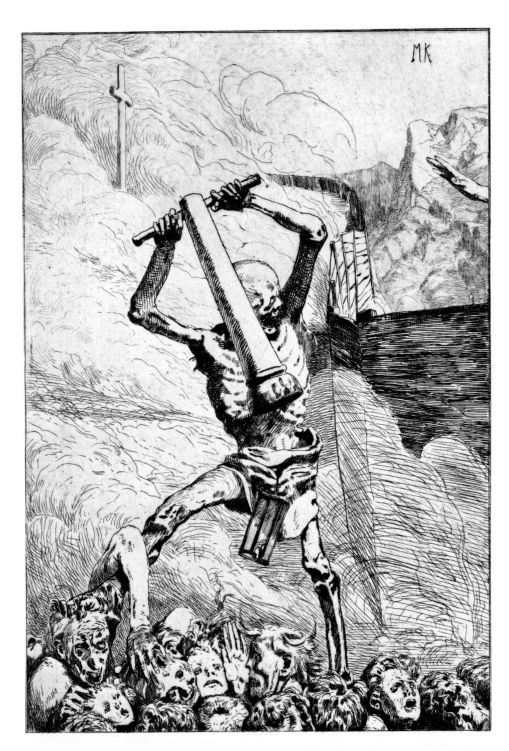

10 Eve and the Future: Third Future

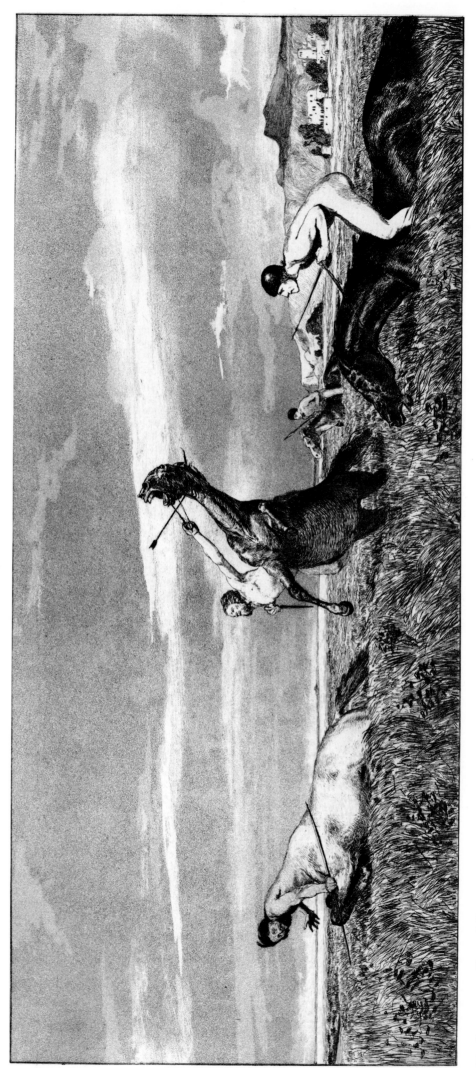

11 Intermezzos: Pursued Centaur

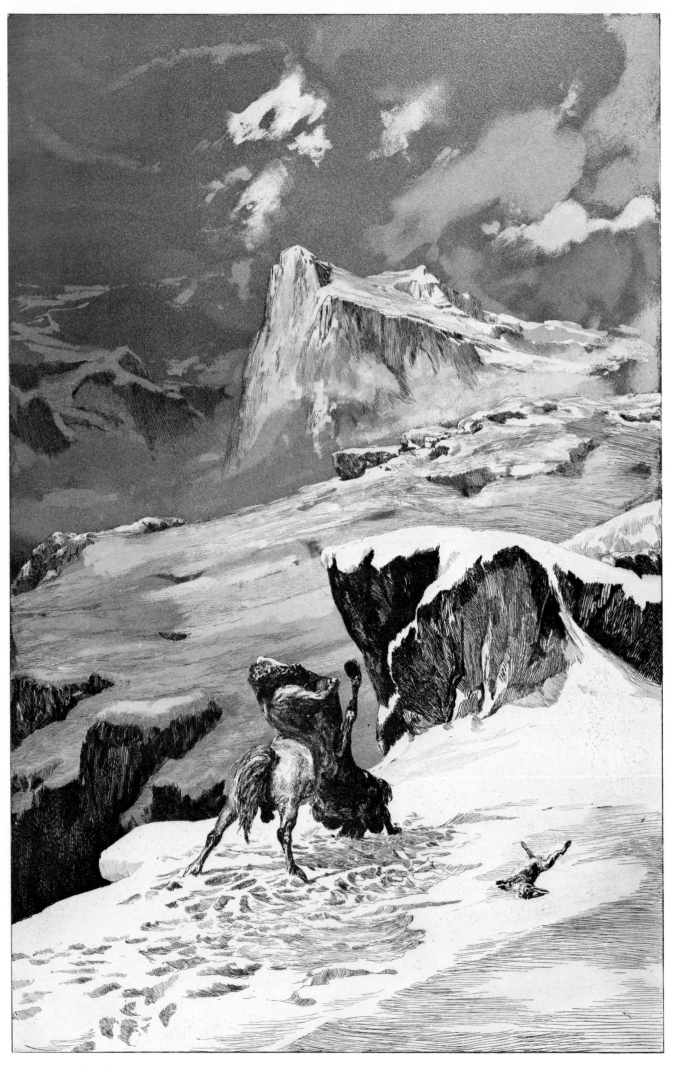

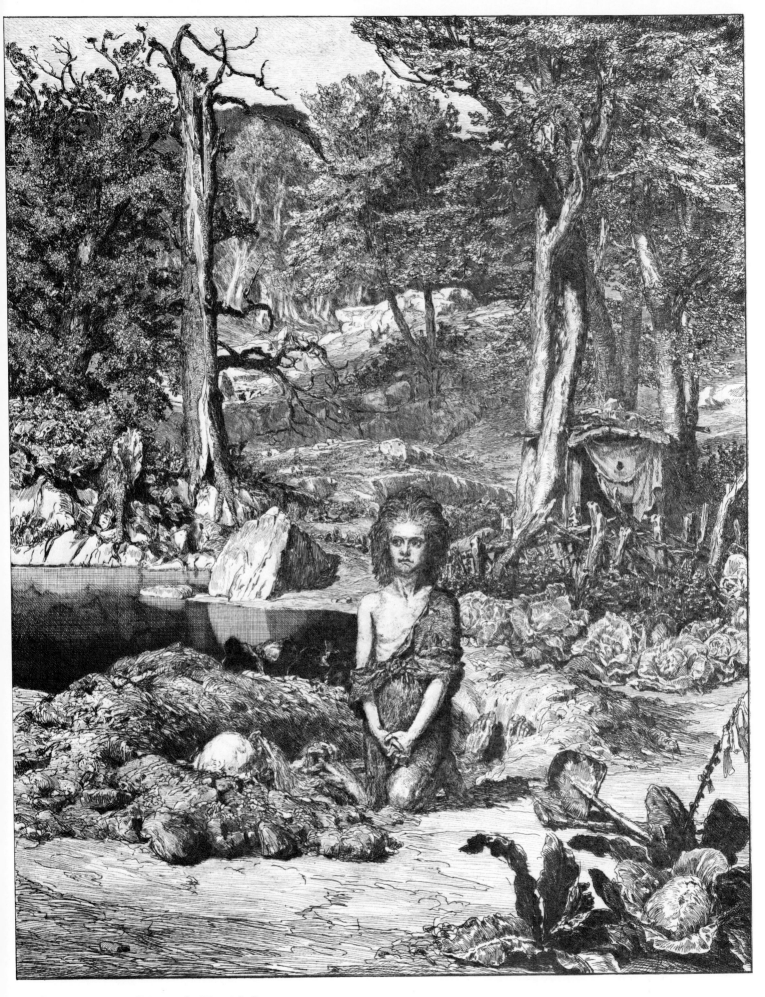

13　Intermezzos: Simplicius at the Hermit's Grave

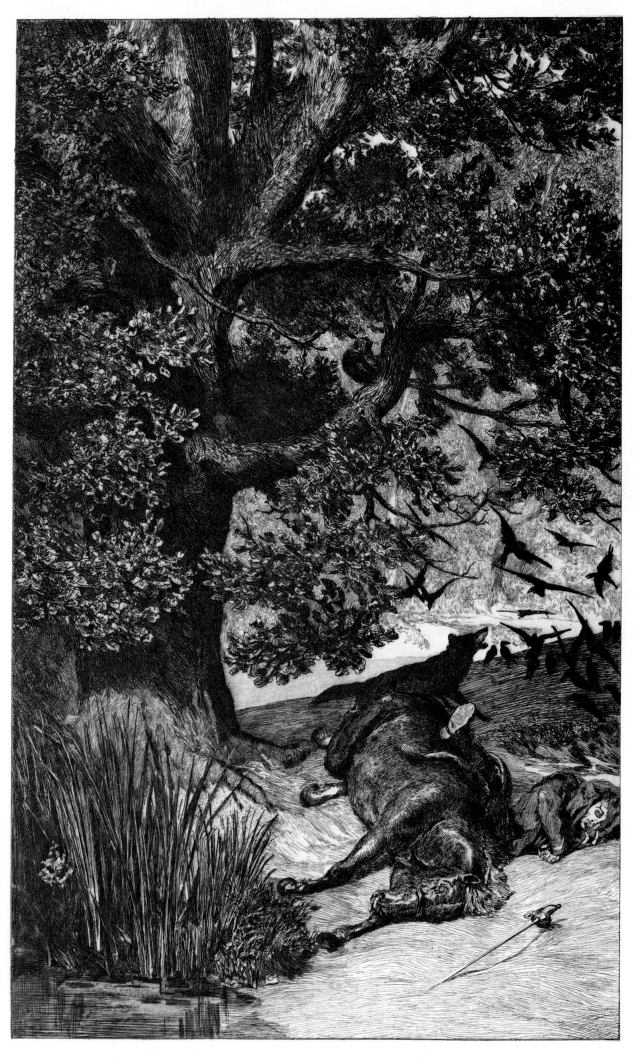

14 Intermezzos: Fallen Rider

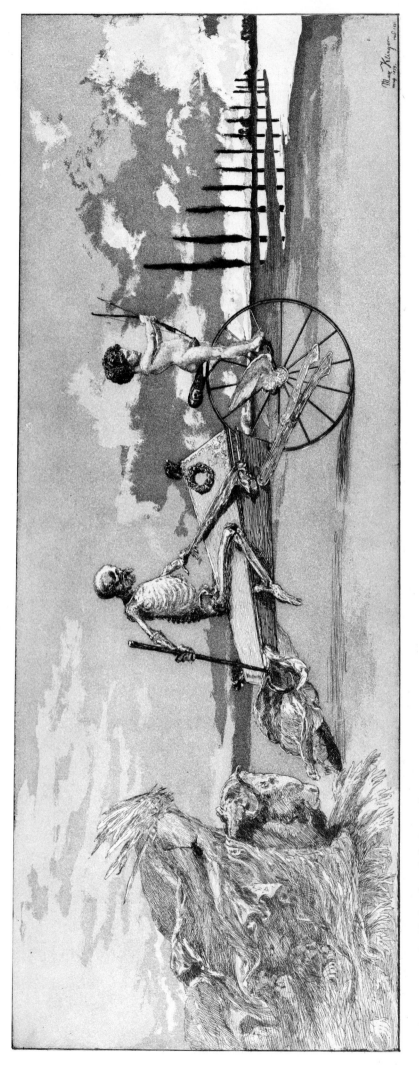

15 Intermezzos: Cupid, Death and the Beyond

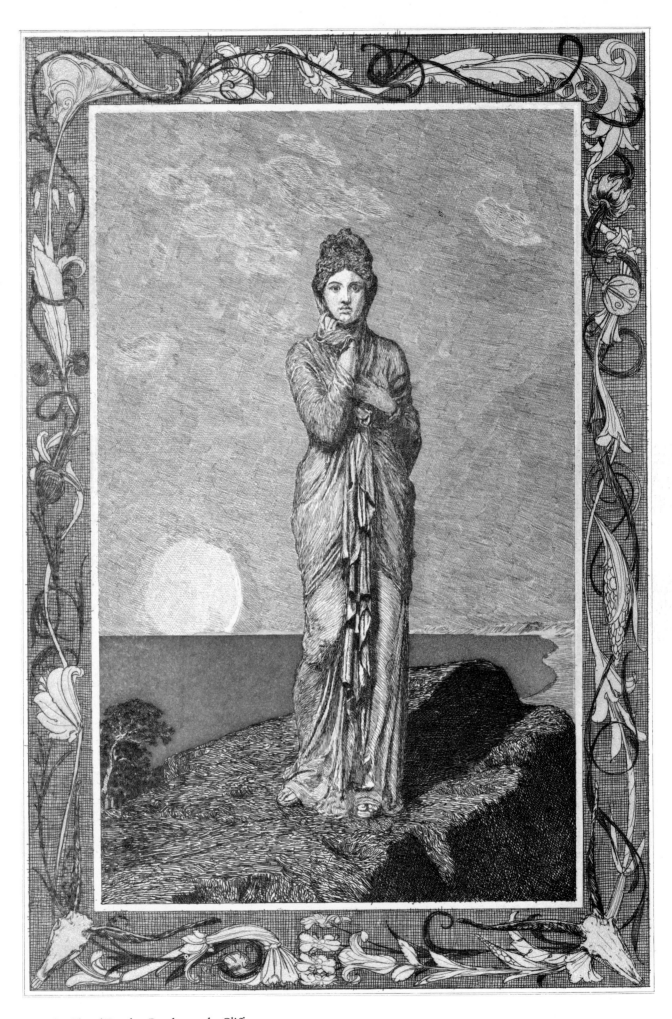

16 Cupid and Psyche: Psyche on the Cliff

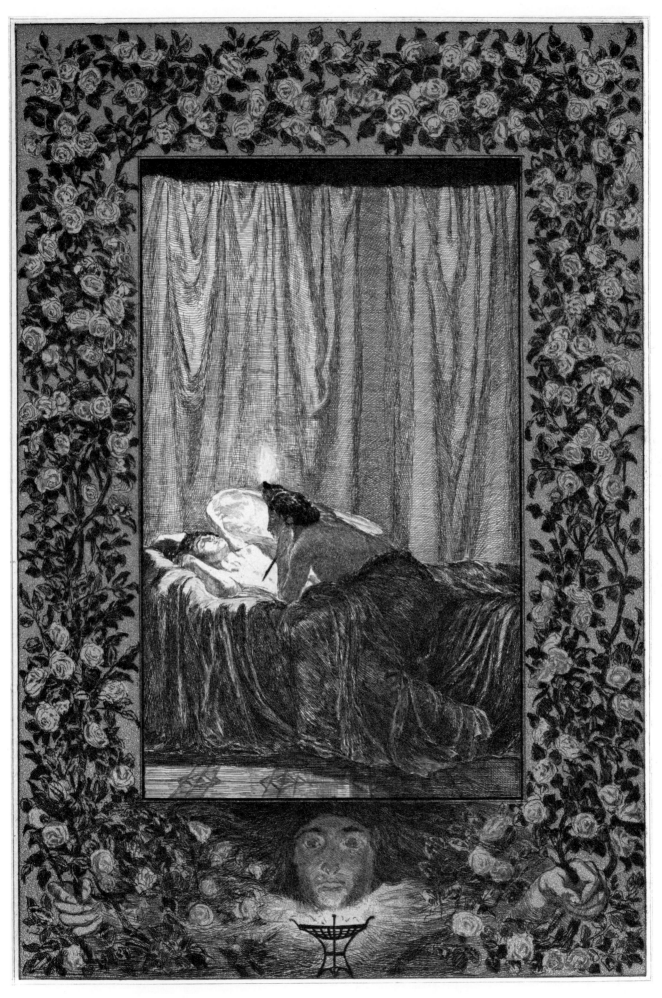

17 Cupid and Psyche: Psyche with the Lamp

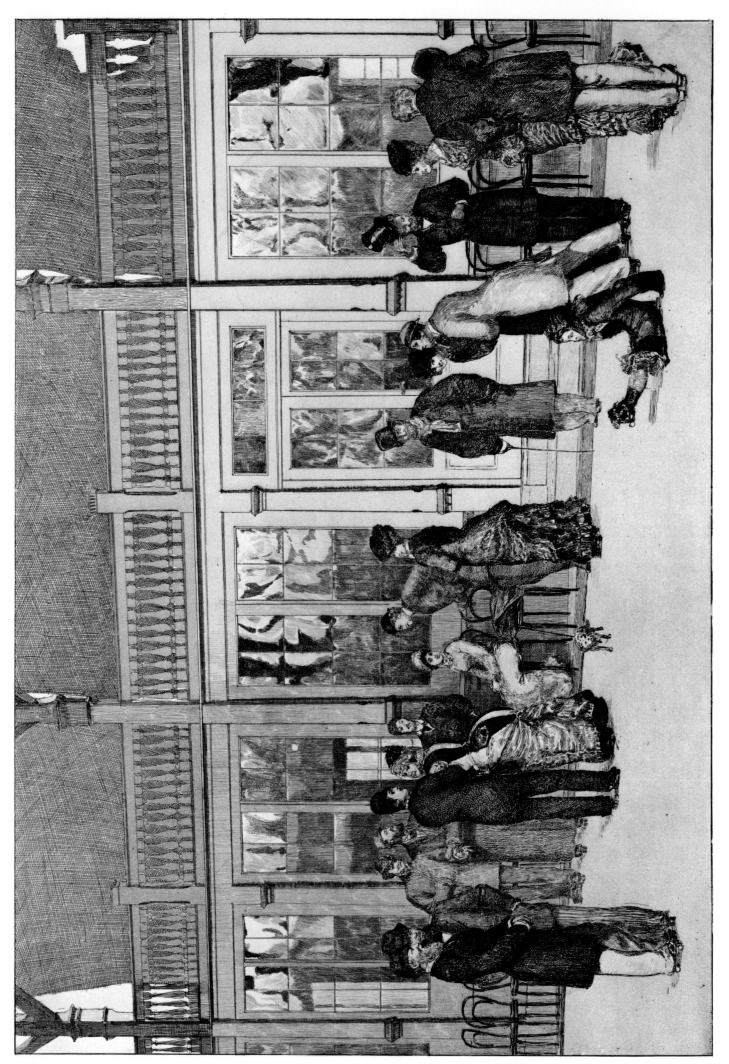

18 A Glove: Place

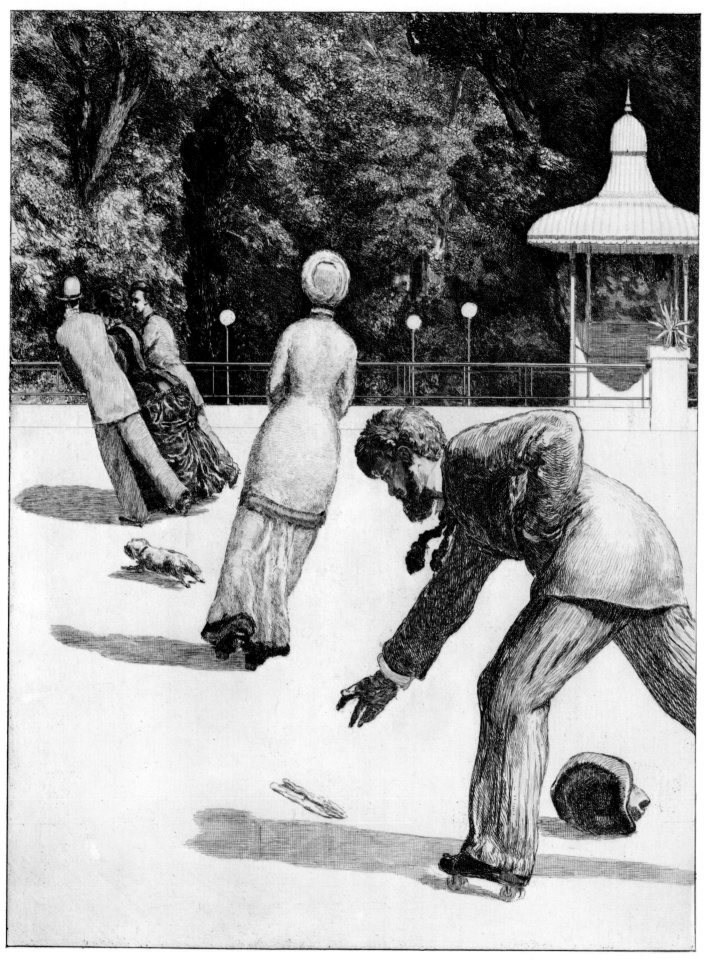

19 A Glove: Action

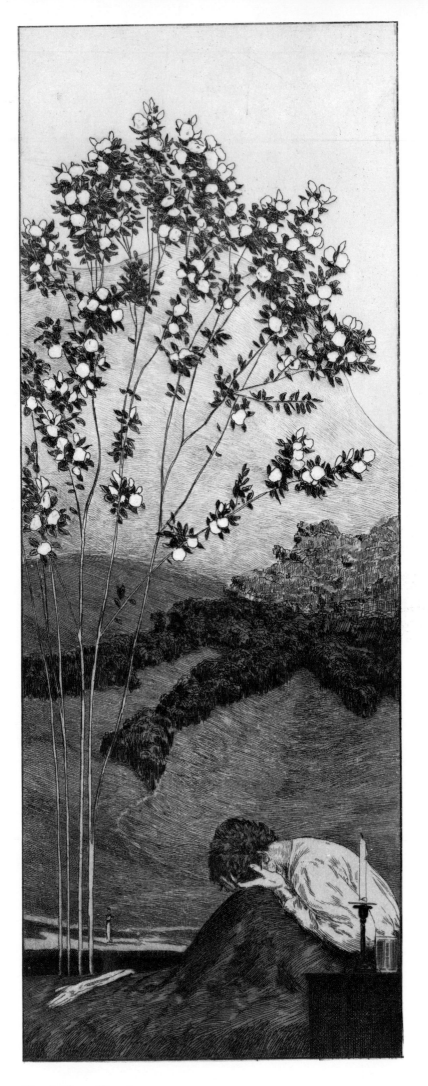

20 A Glove: Yearnings

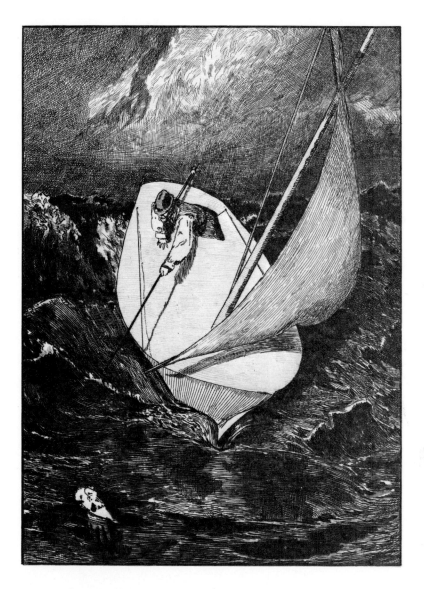

21 A Glove: Rescue

22 A Glove: Triumph

23 A Glove: Homage

24 A Glove: Anxieties

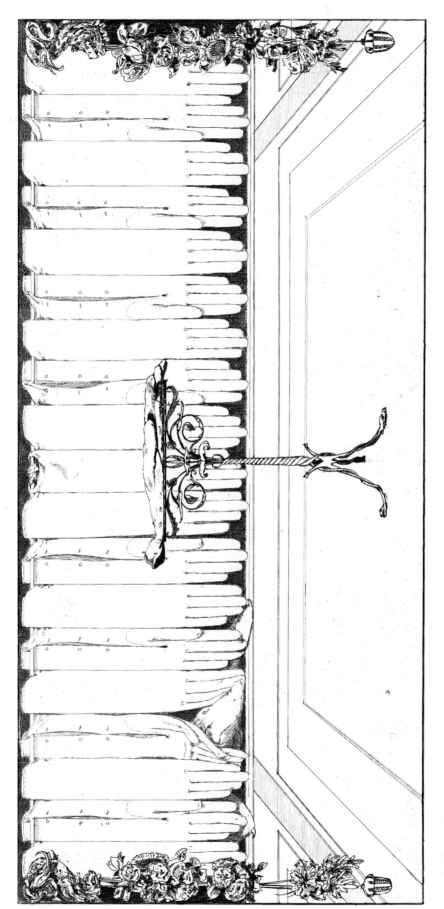

25　A Glove: Repose

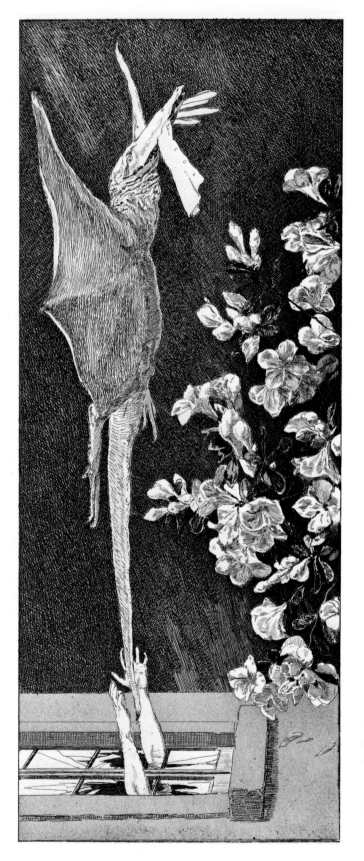

26 A Glove: Abduction

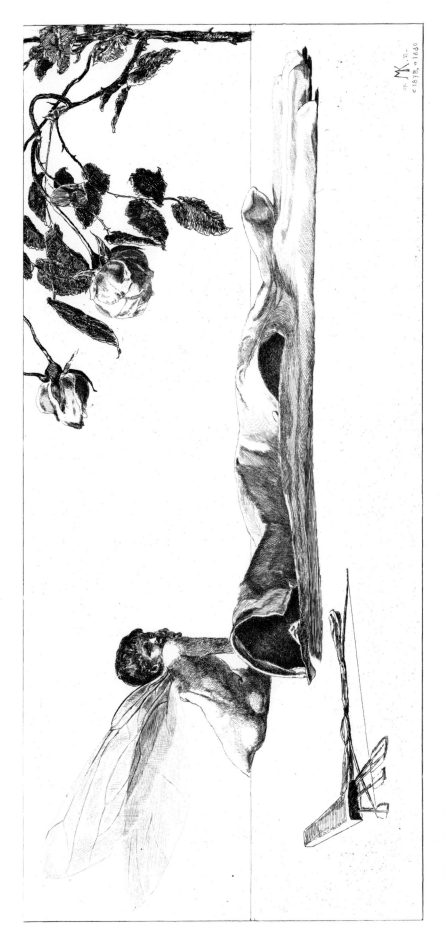

27 A Glove: Cupid

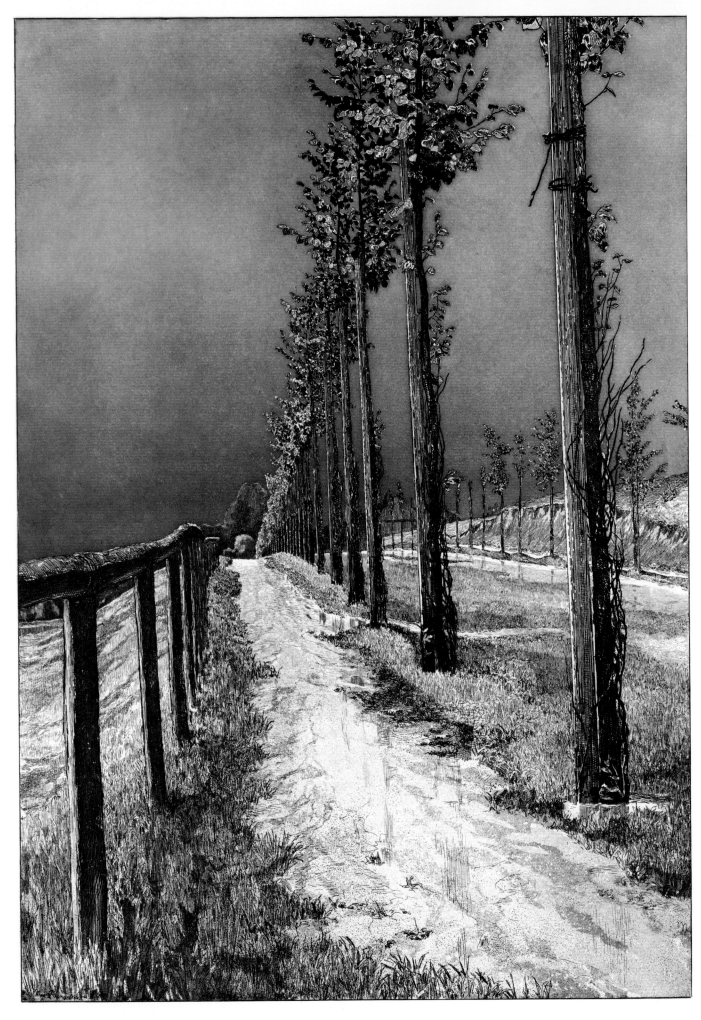

28 Four Landscapes: The Road

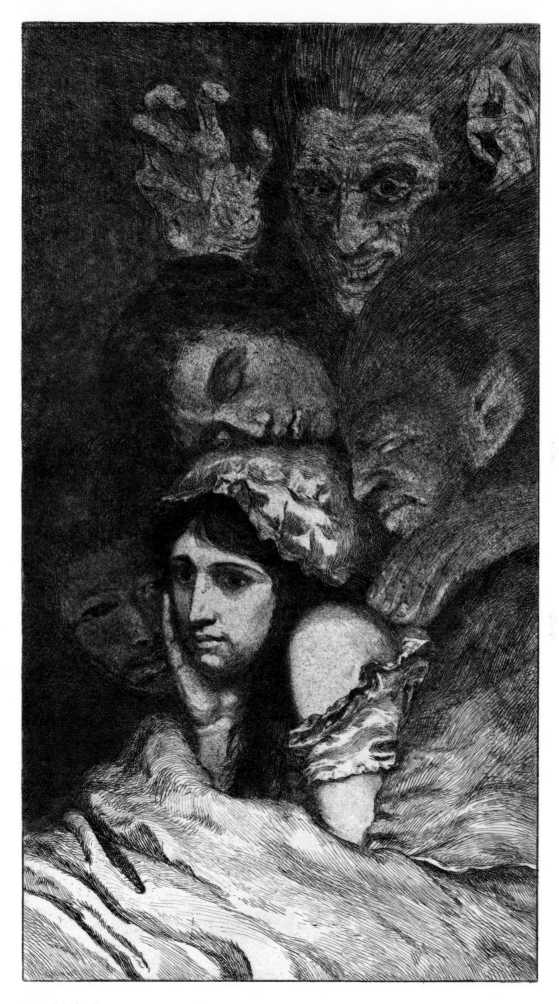

29 A Life: Dreams

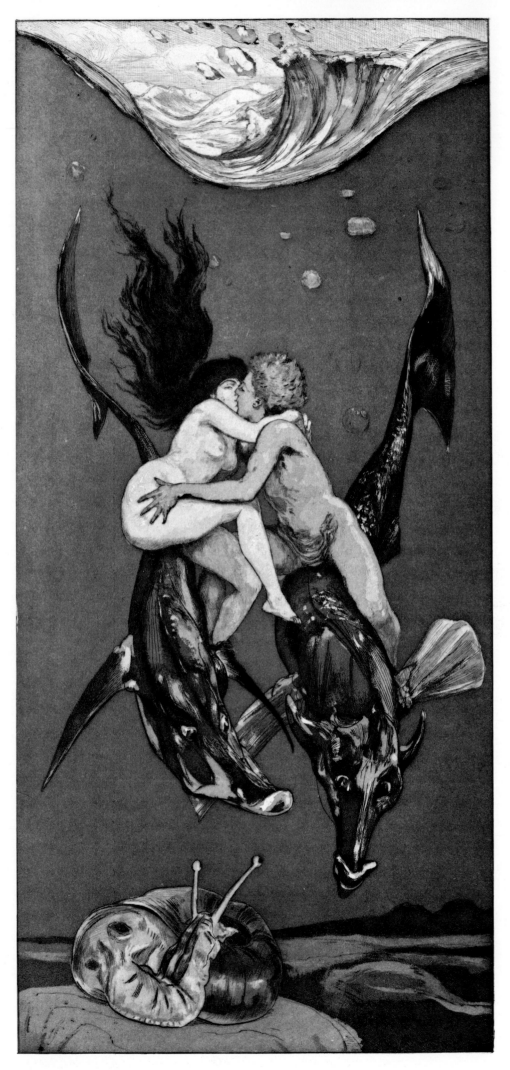

31 A Life: Abandoned

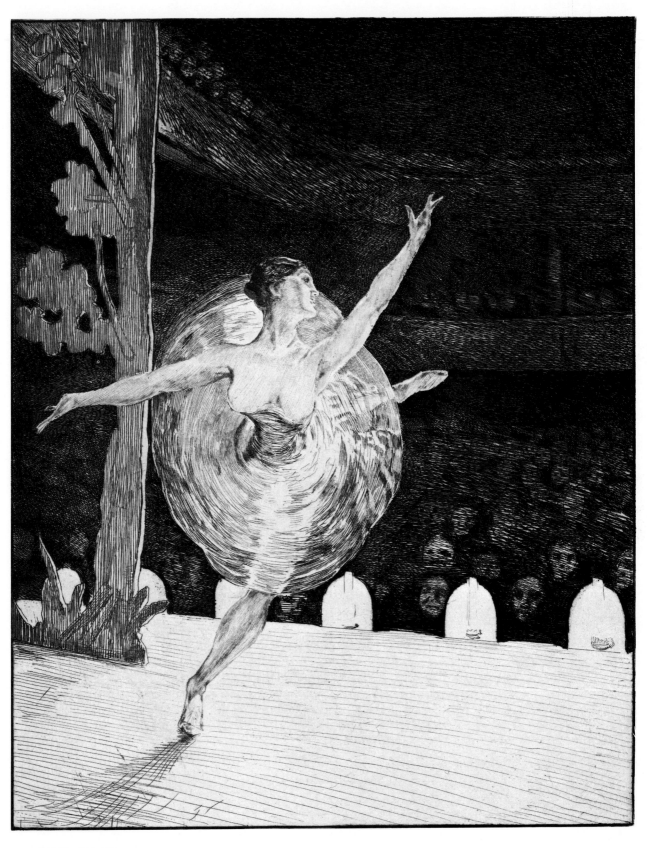

32 A Life: For All

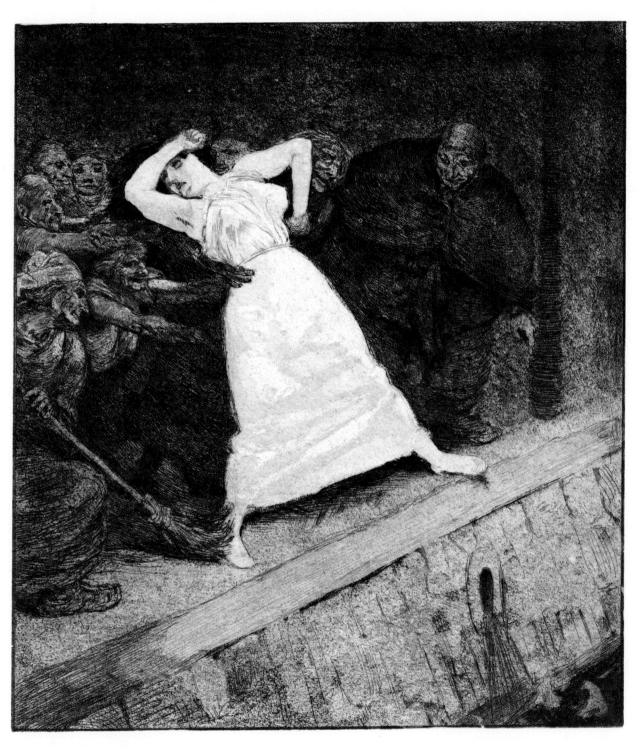

33 A Life: Into the Gutter!

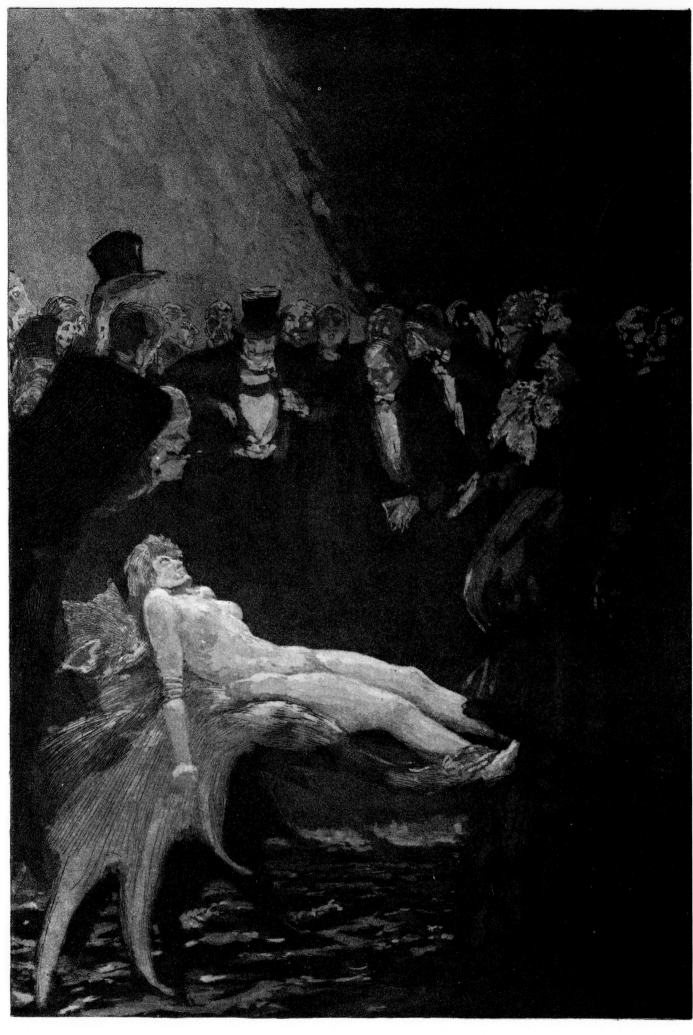

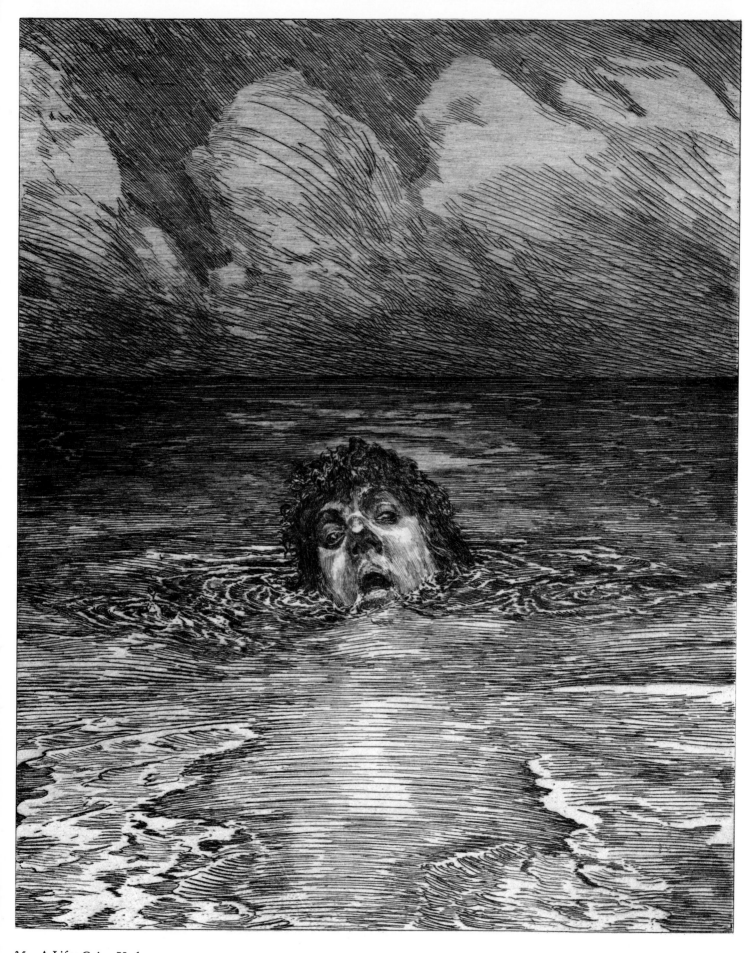

35 A Life: Going Under

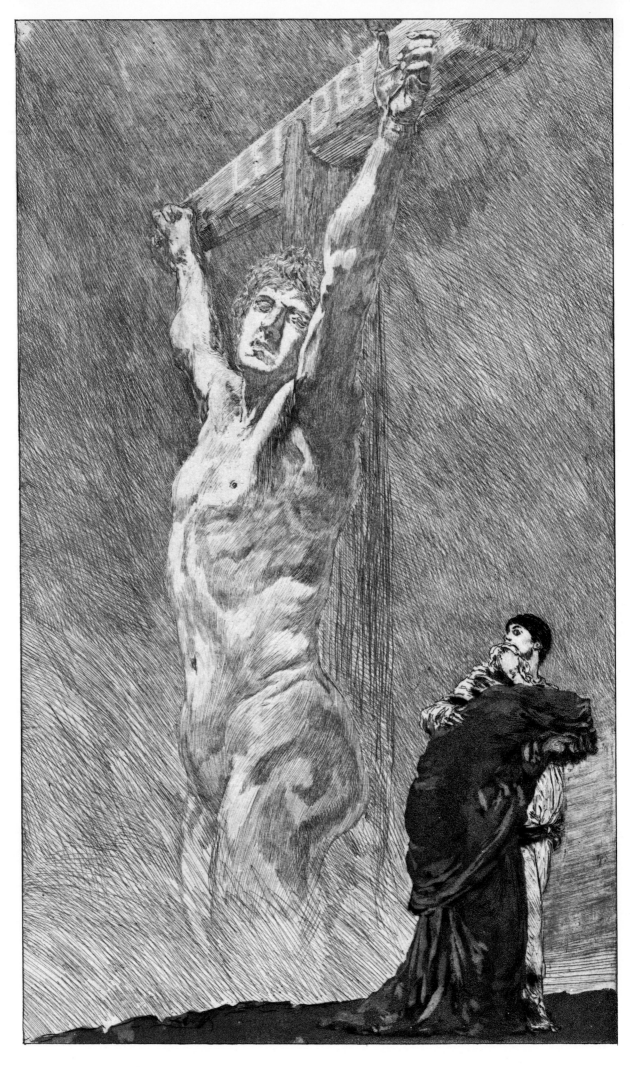

36 A Life: Suffer!

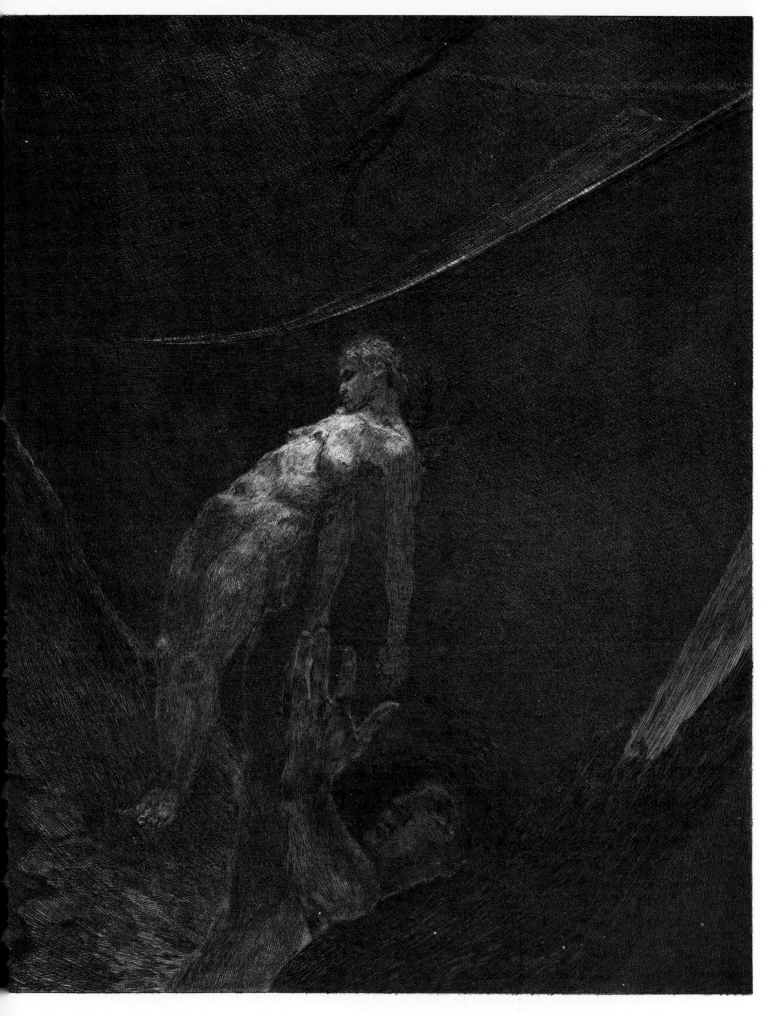

A Life: Back into Nothingness

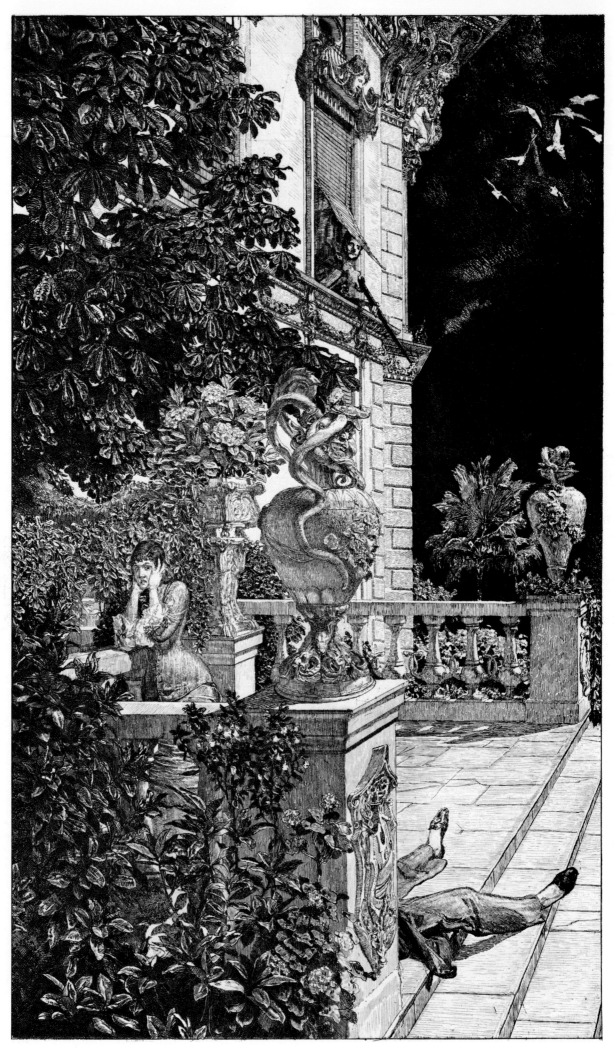

38 Dramas: In Flagranti

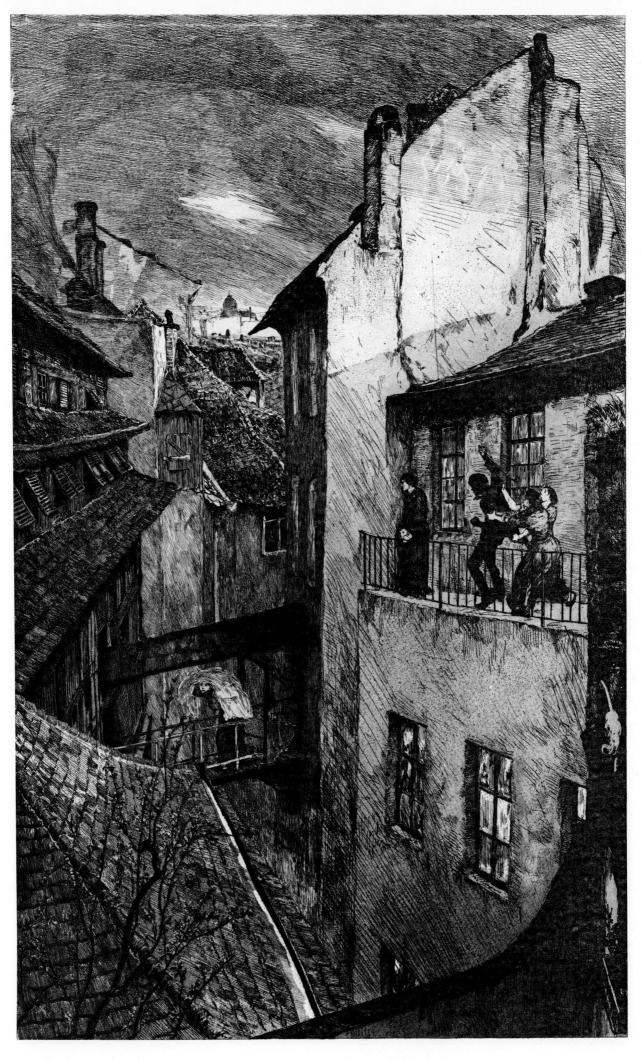

39 Dramas: A Mother I

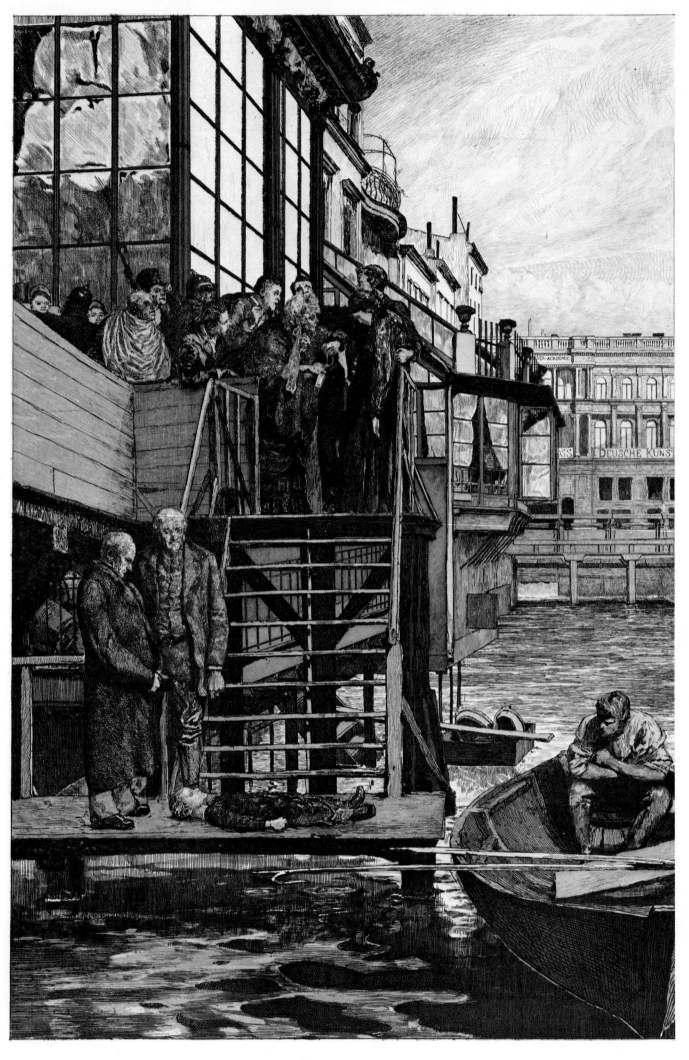

40 Dramas: A Mother II

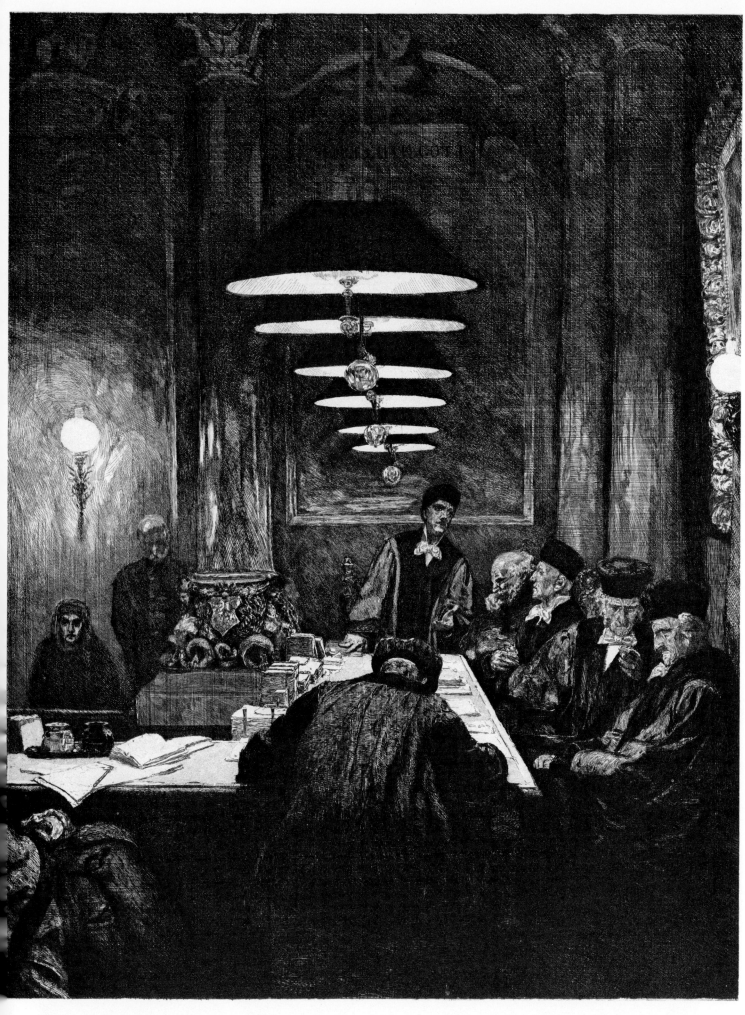

41 Dramas: A Mother III

42 Dramas: In the Woods

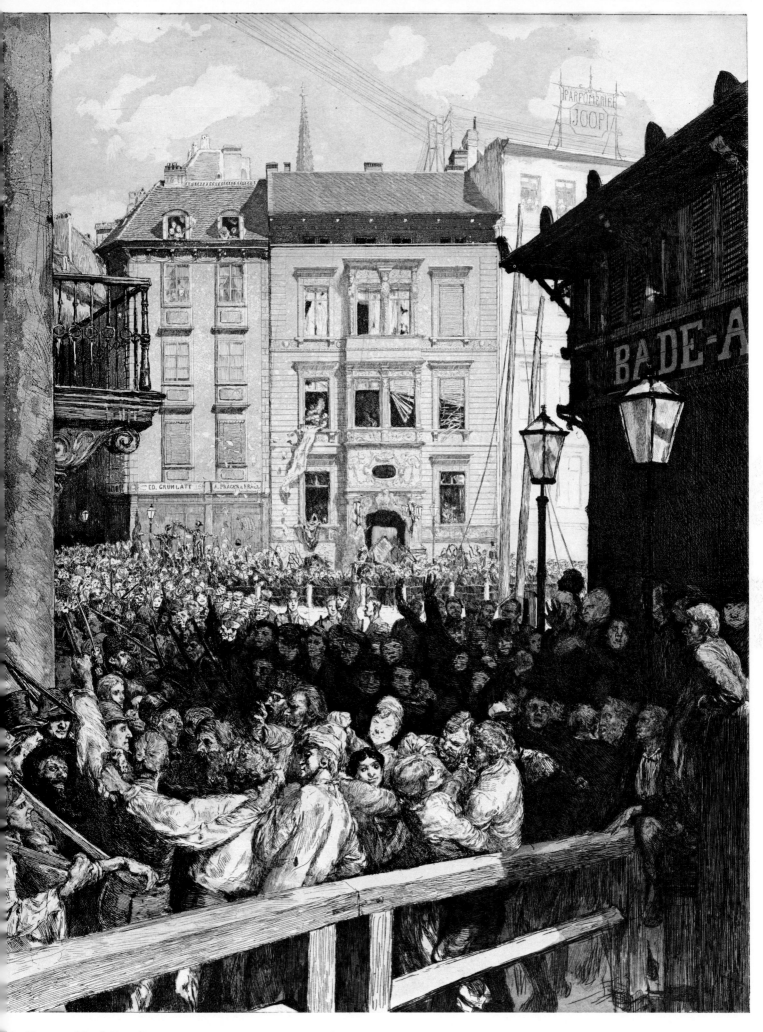

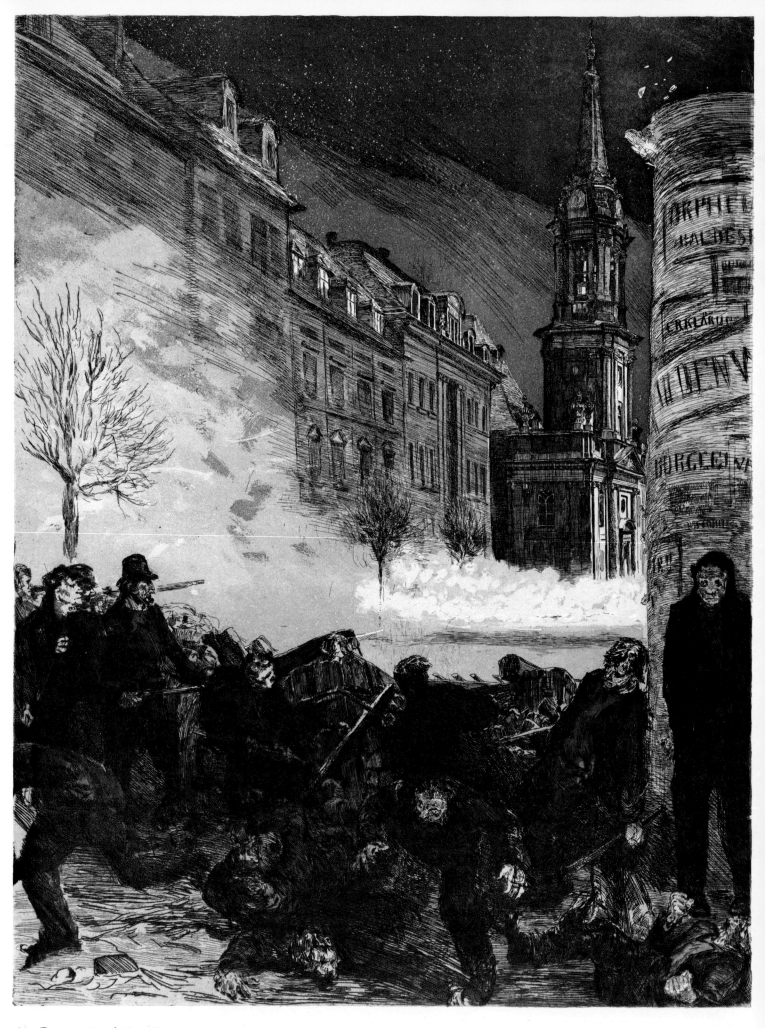

44 Dramas: March Days II

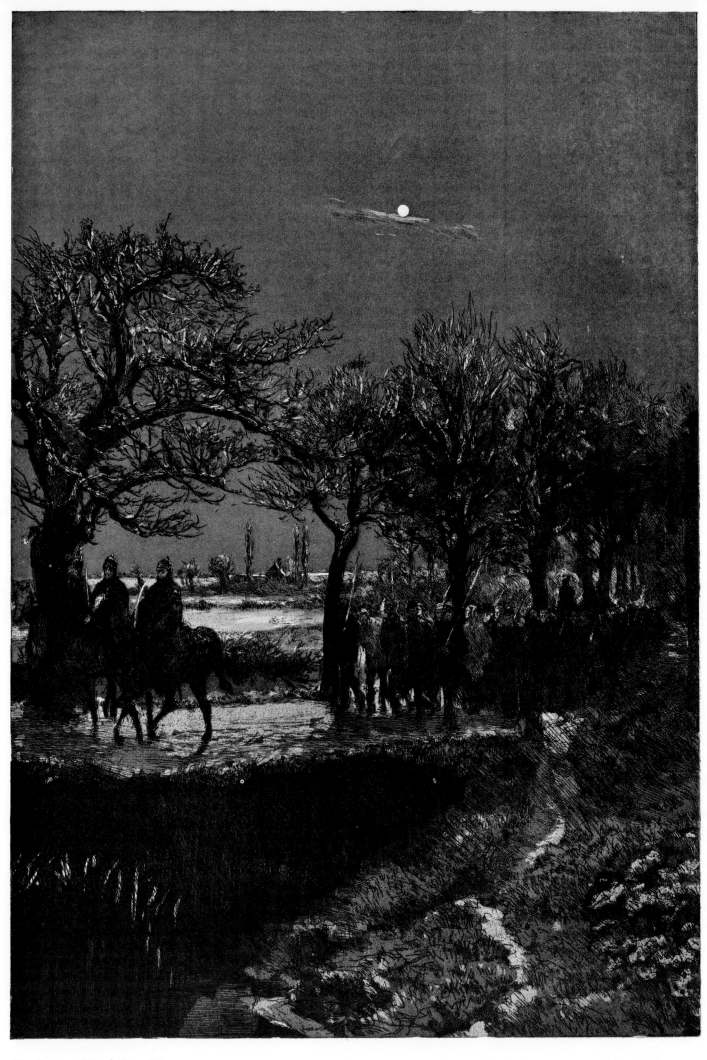

45 Dramas: March Days III

AN

ARNOLD BÖCKLIN

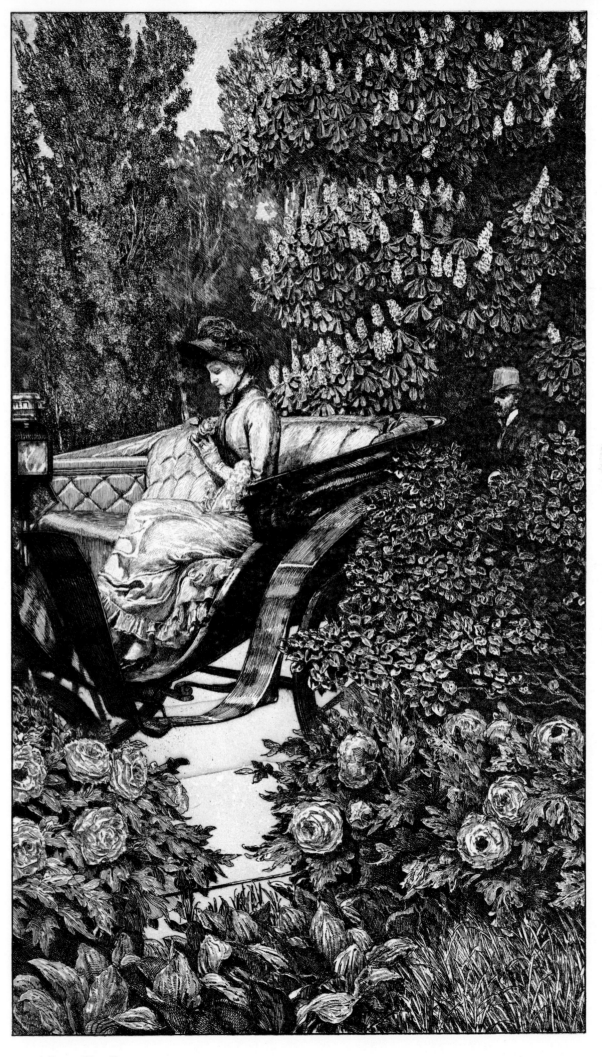

47 A Love: First Encounter

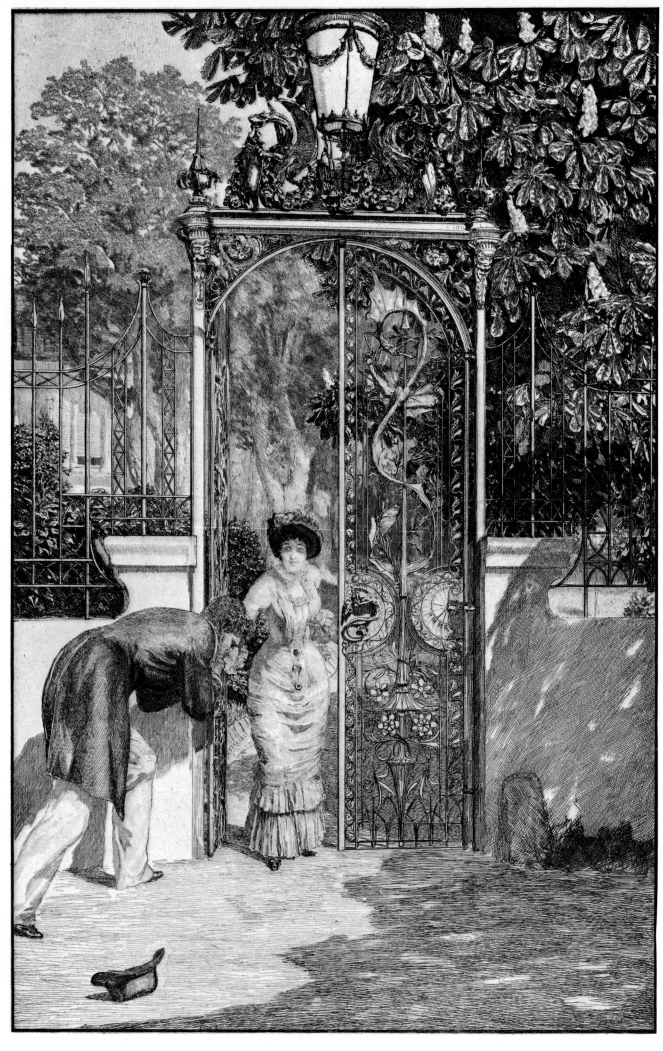

48 A Love: At the Gate

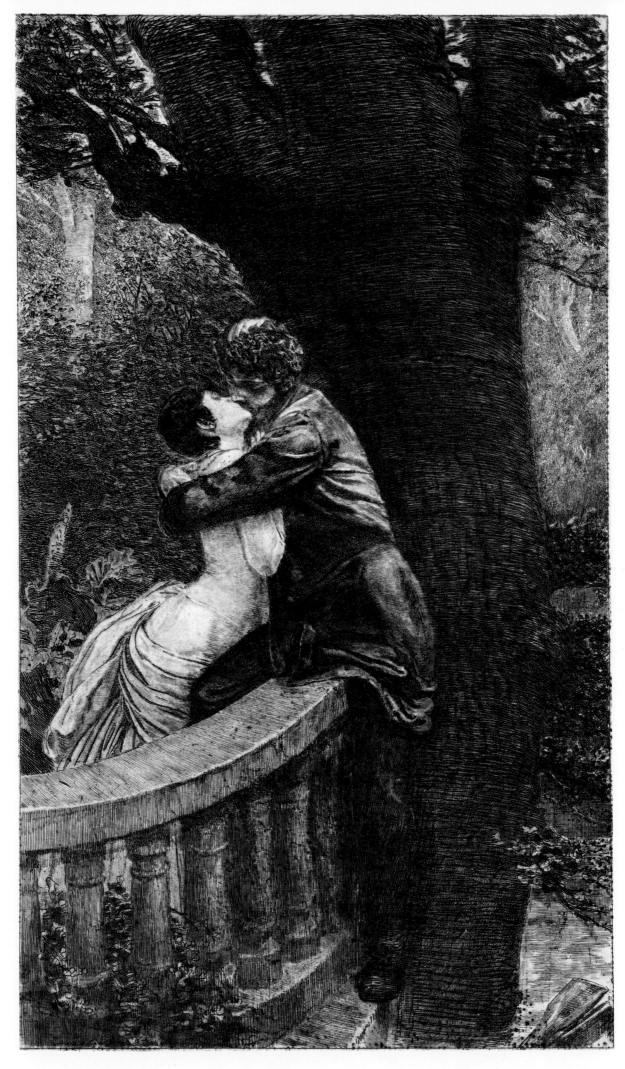

49 A Love: In the Park

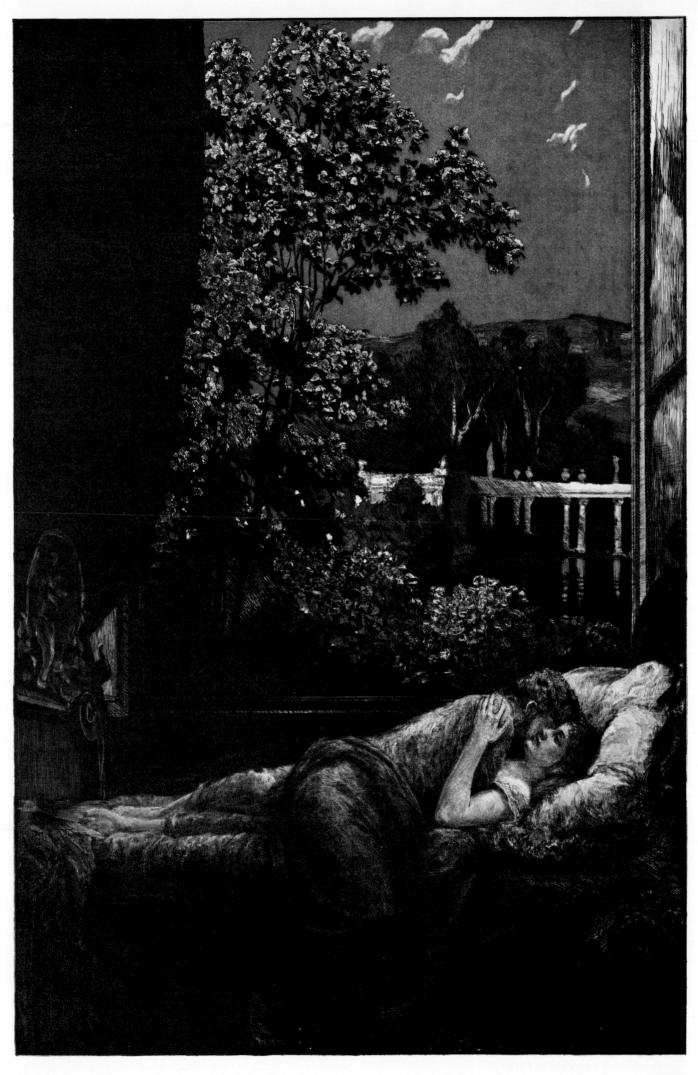

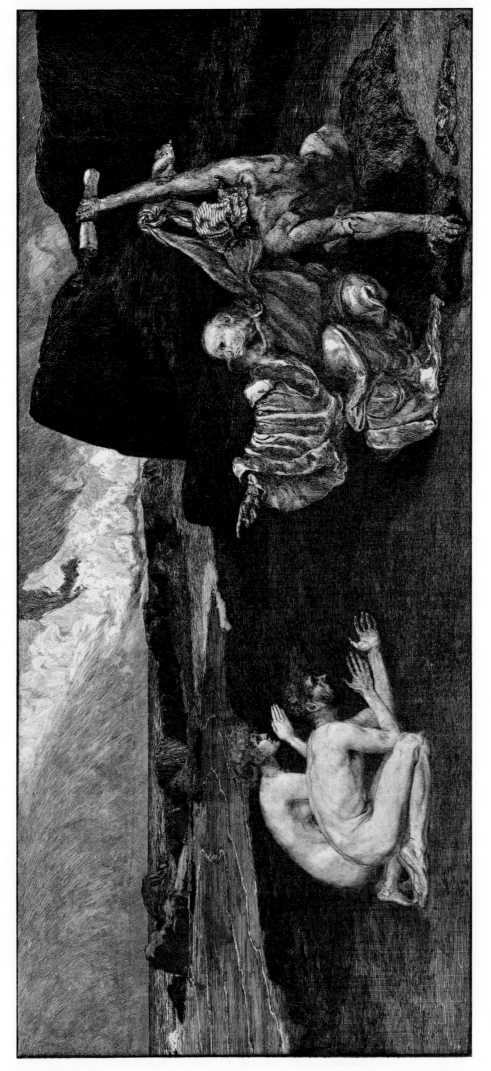

51 A Love: Intermezzo

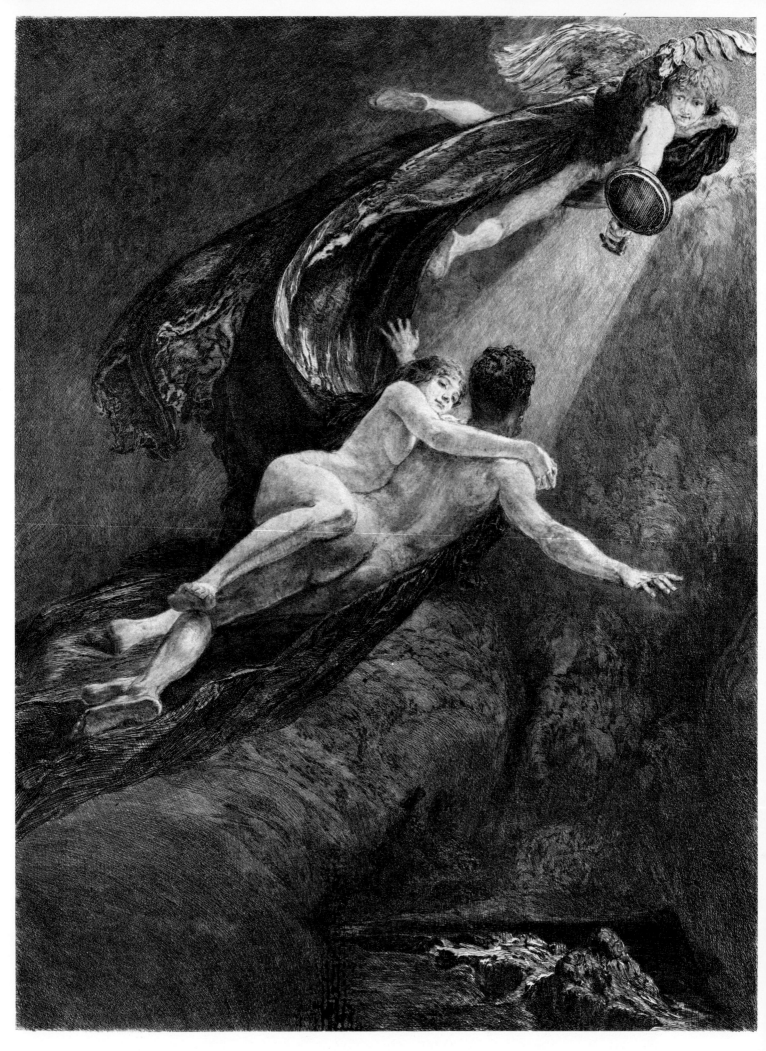

52 A Love: New Dreams of Happiness

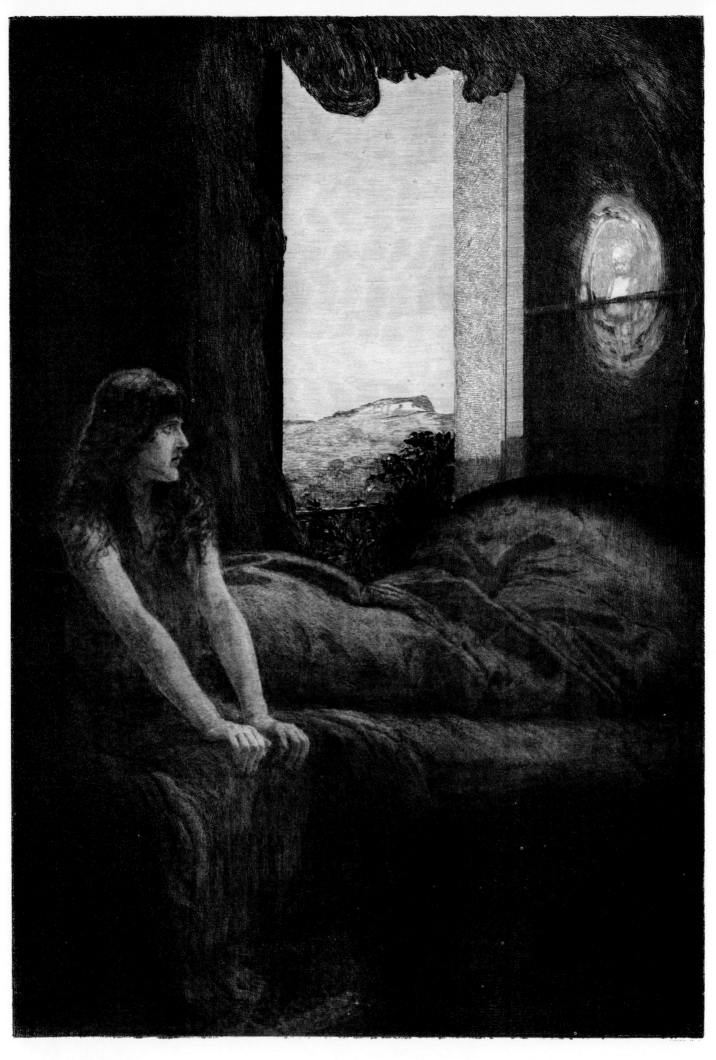

53 A Love: Awakening

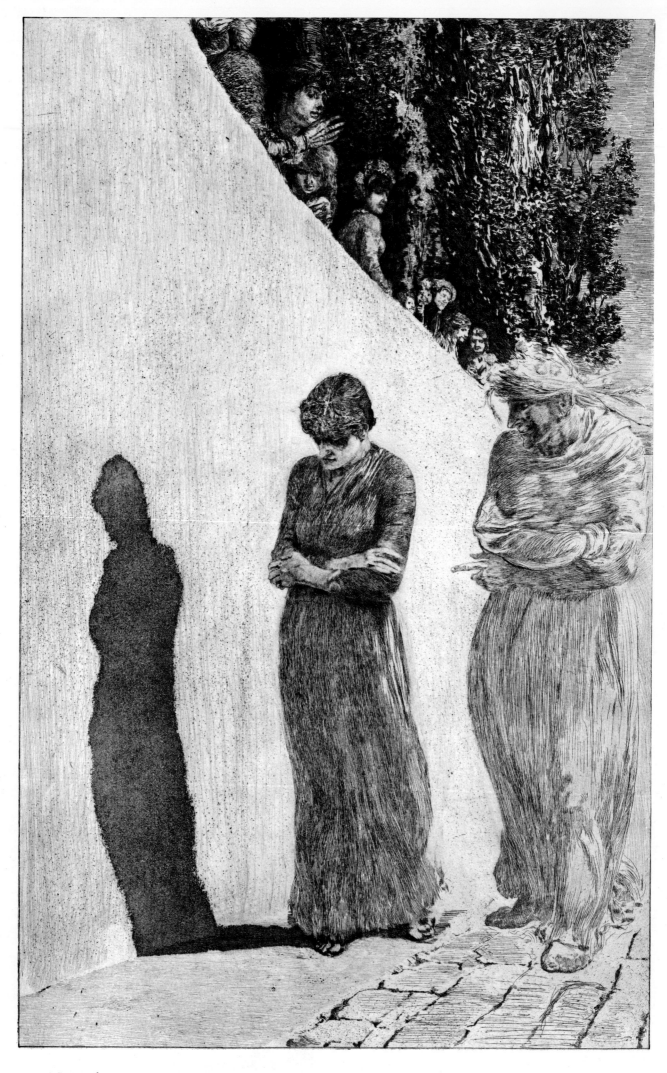

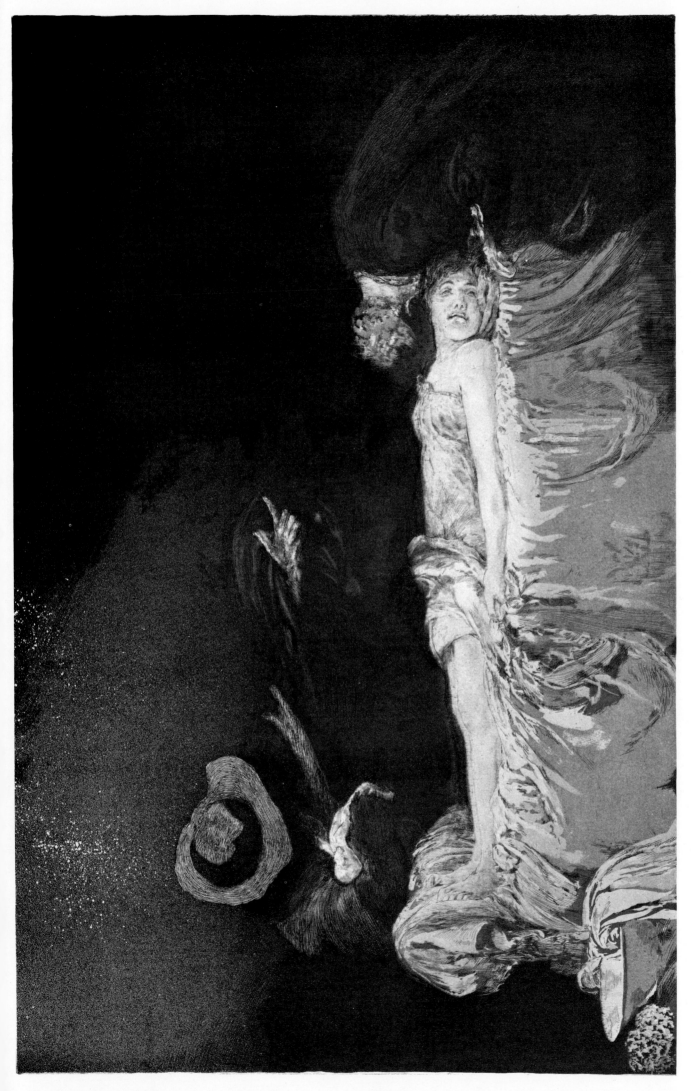

55 A Love: Death

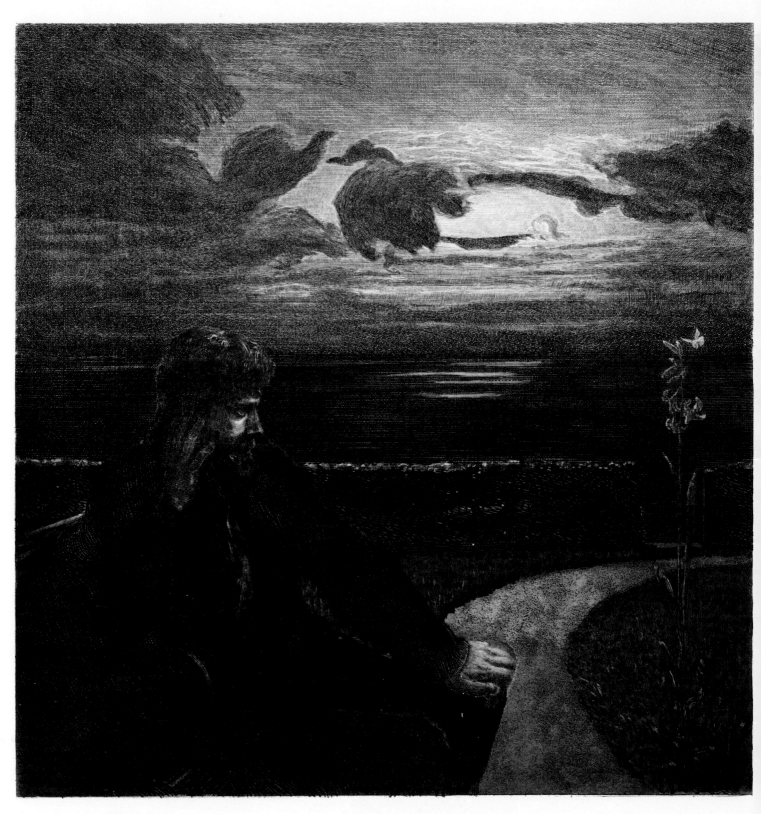

56 On Death, Part I: Night

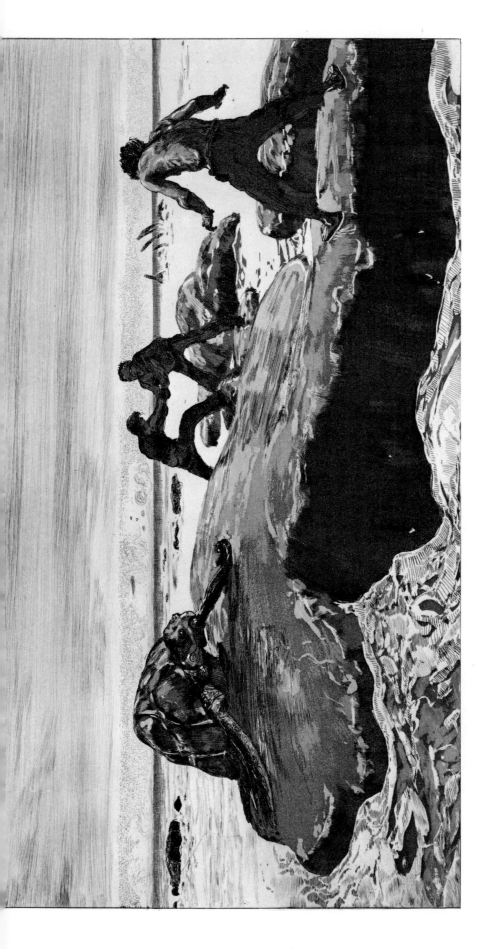

57 On Death, Part I: Sailors

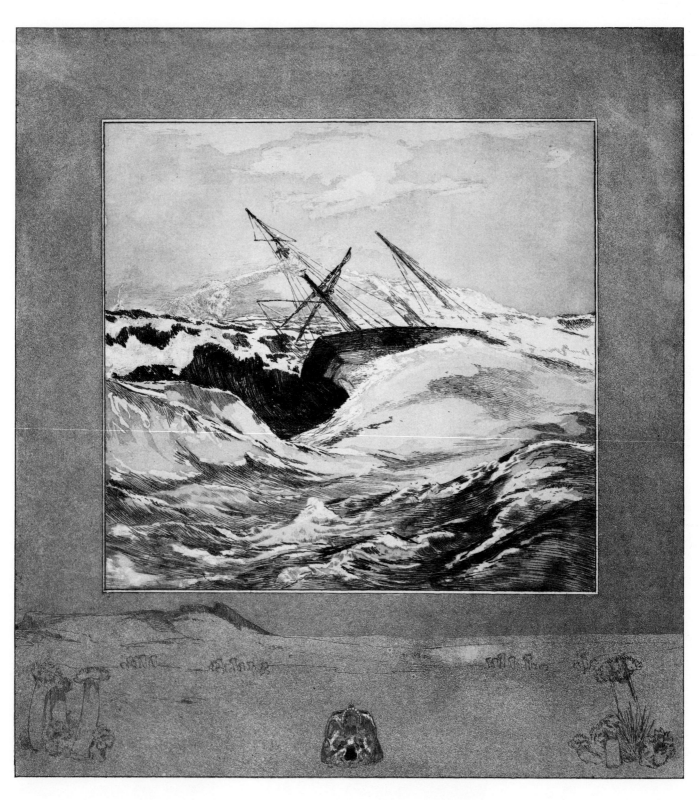

58 On Death, Part I: Sea

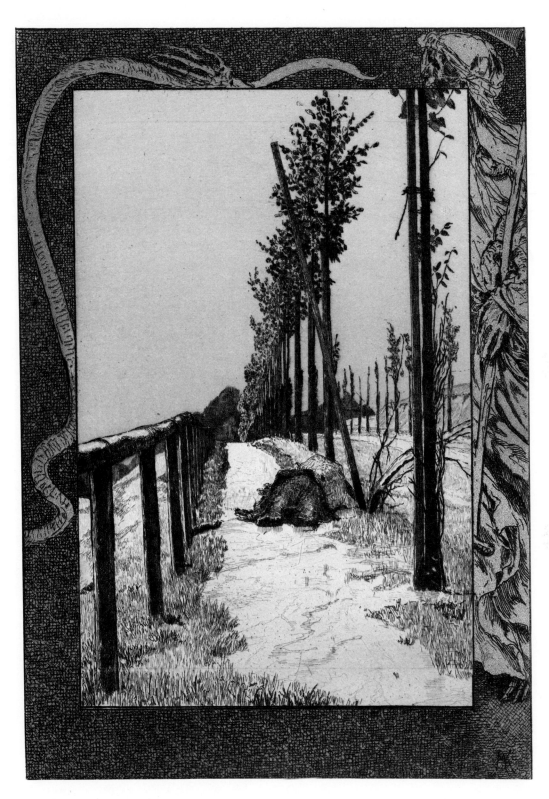

59 On Death, Part I: Road

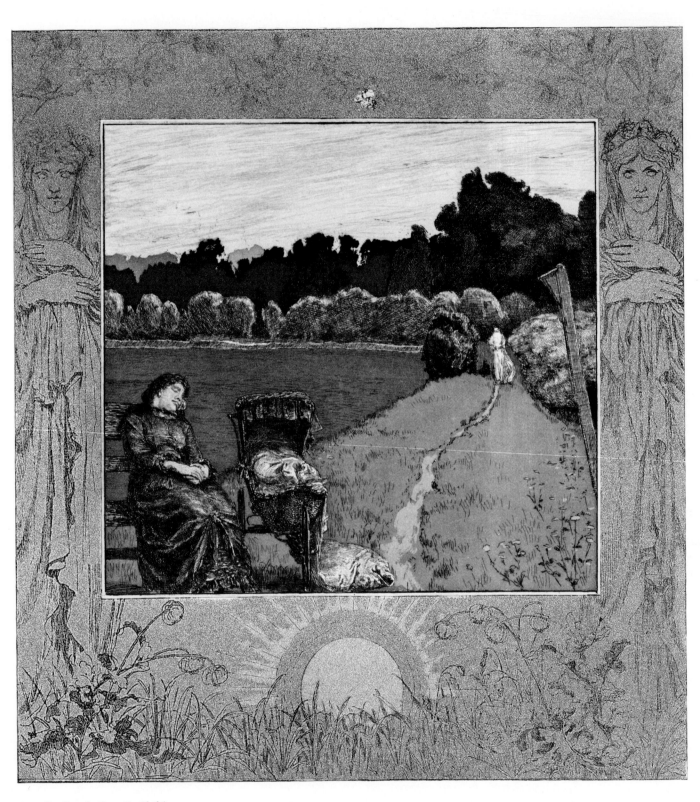

60 On Death, Part I: Child

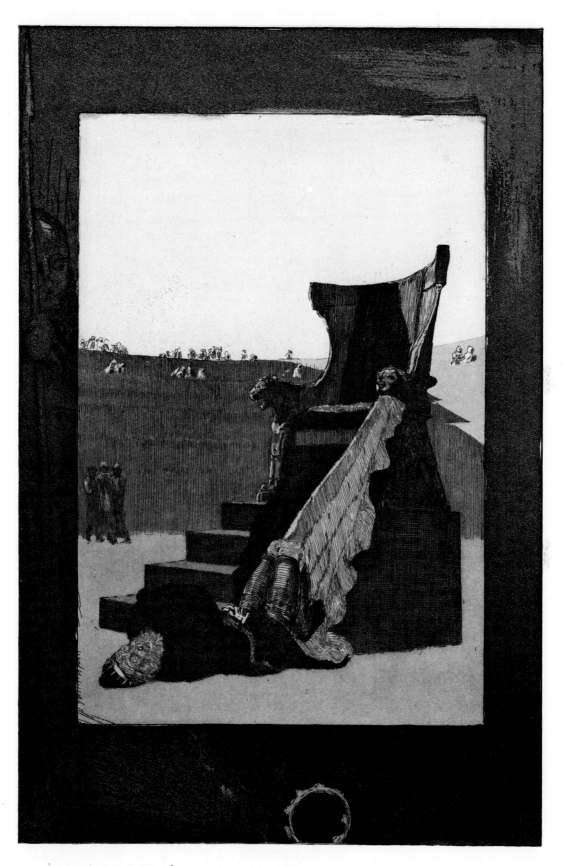

61 On Death, Part I: Herod

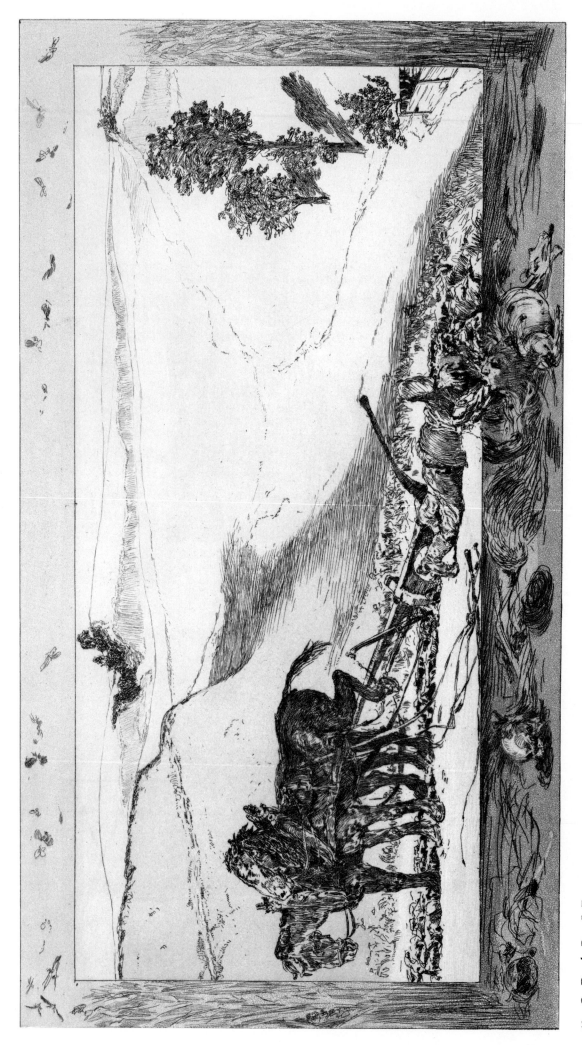

62 On Death, Part I: Farmer

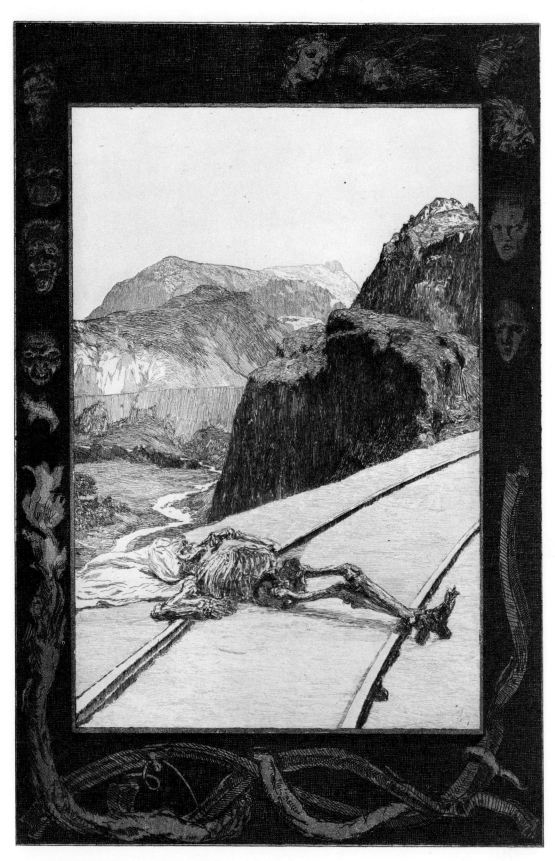

63 On Death, Part I: On the Tracks

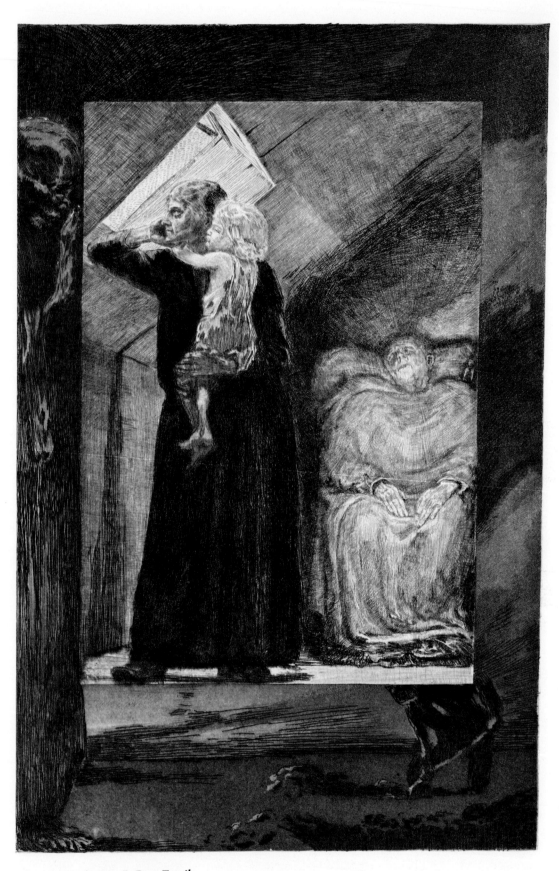

64 On Death, Part I: Poor Family

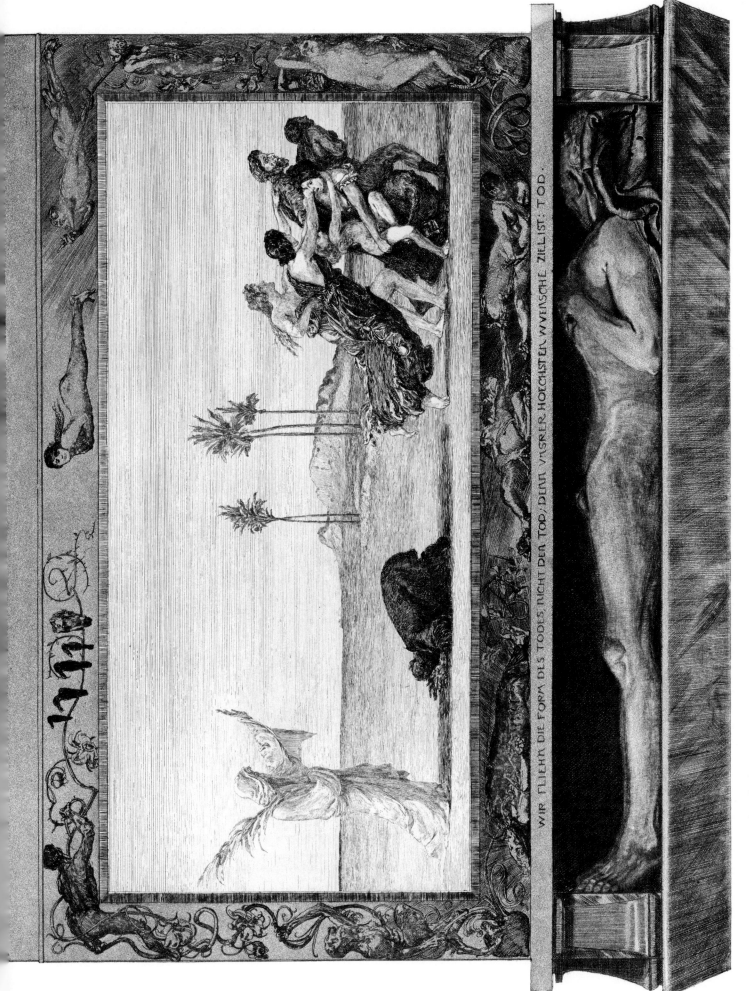

WIR FLIEHN DIE FORM DES TODES, NICHT DEN TOD, DENN VNSRER HOECHSTEN WVENSCHE ZIEL IST: TOD.

65 On Death, Part I: Death as Savior

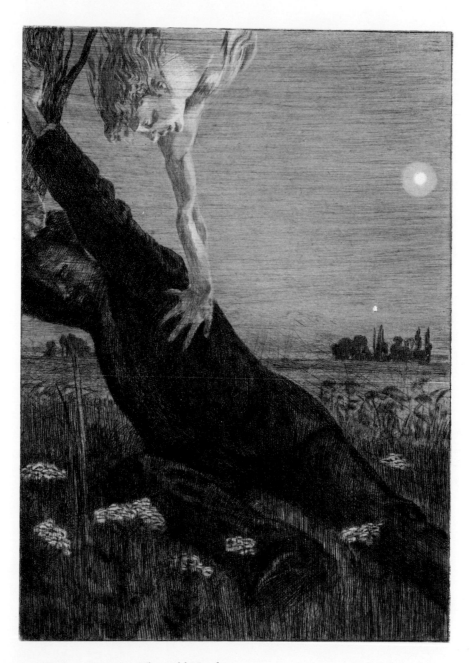

66 Brahms Fantasies: The Cold Hand

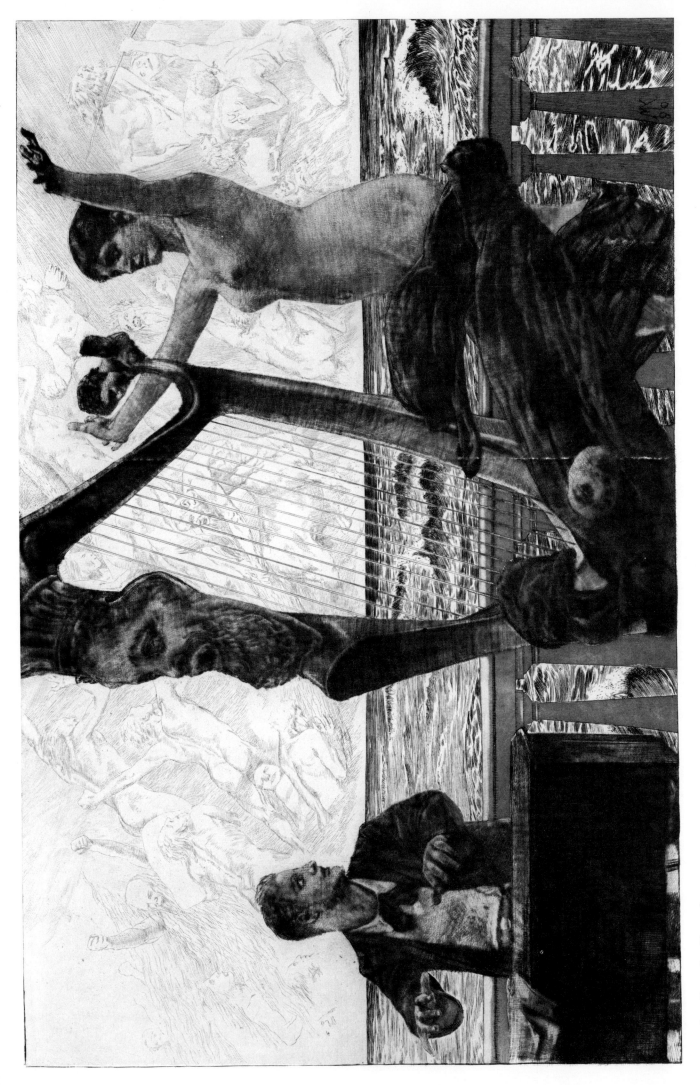

67 Brahms Fantasies: Evocation

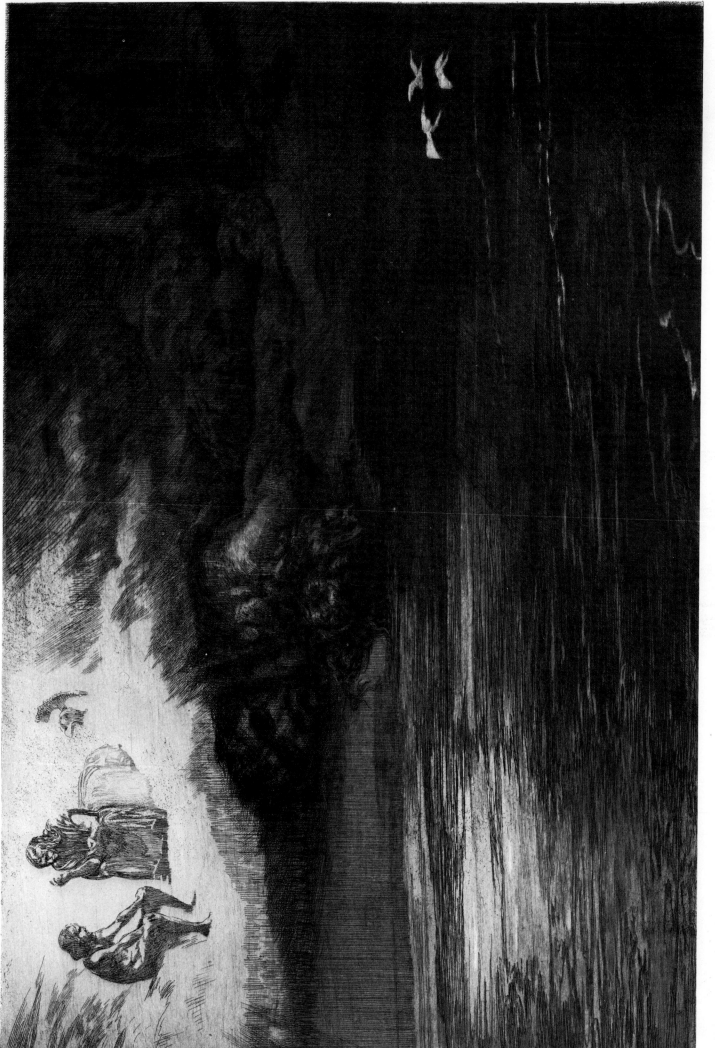

68　Brahms Fantasies: Night

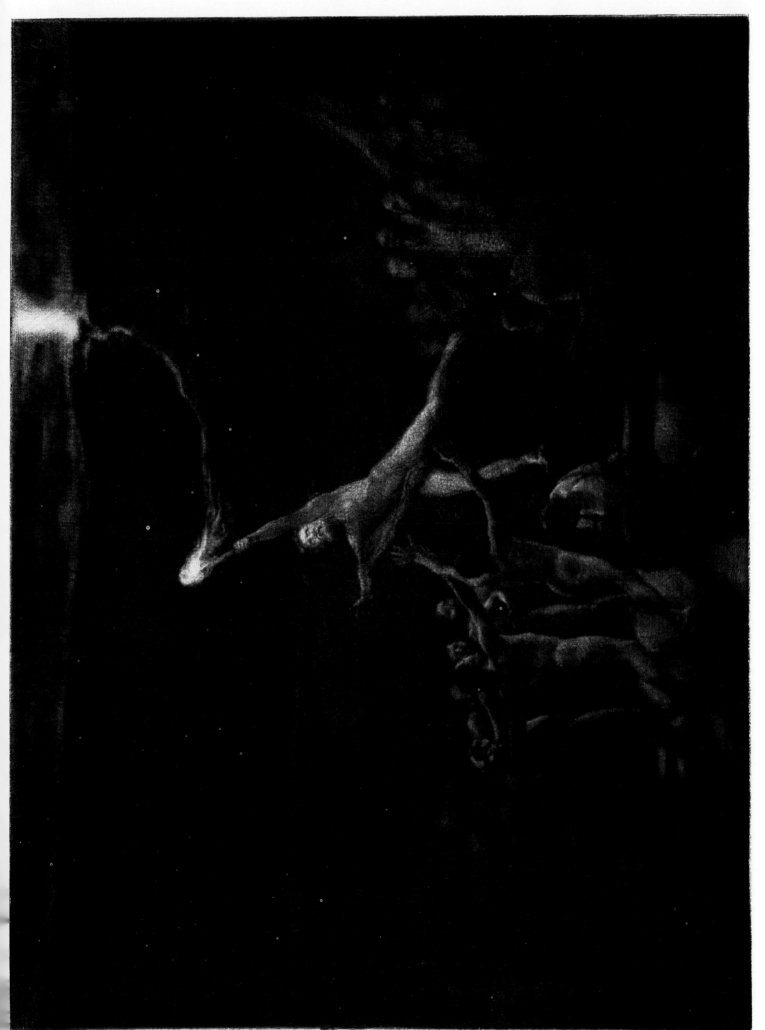

69 Brahms Fantasies: Theft of Light

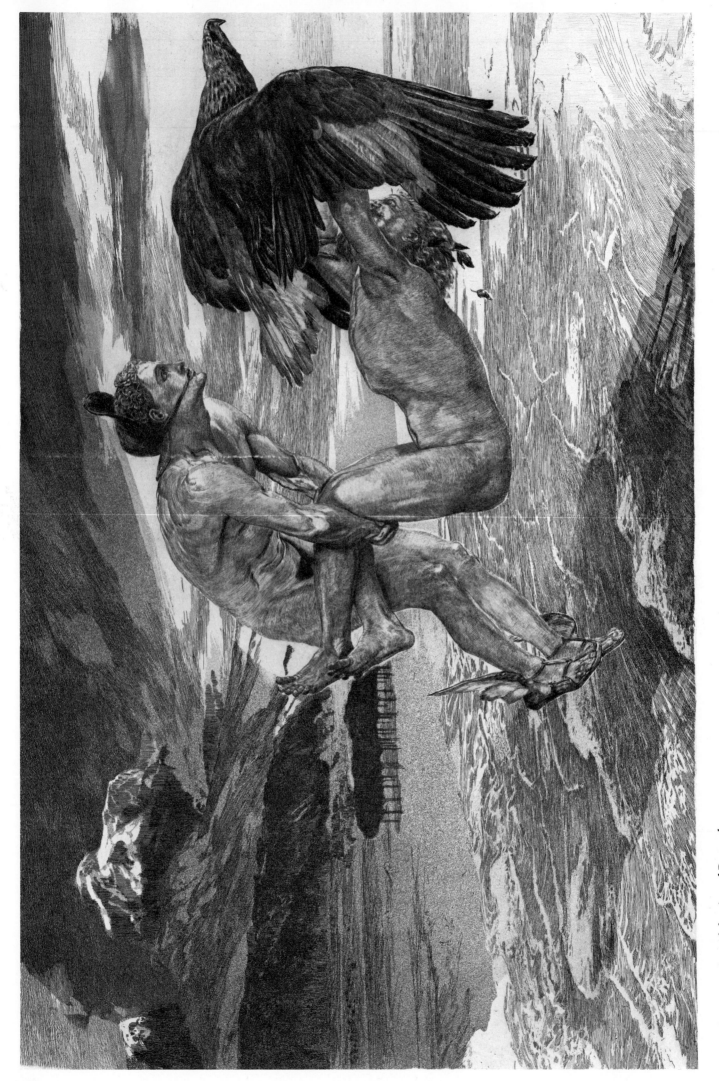

70 Brahms Fantasies: Abduction of Prometheus

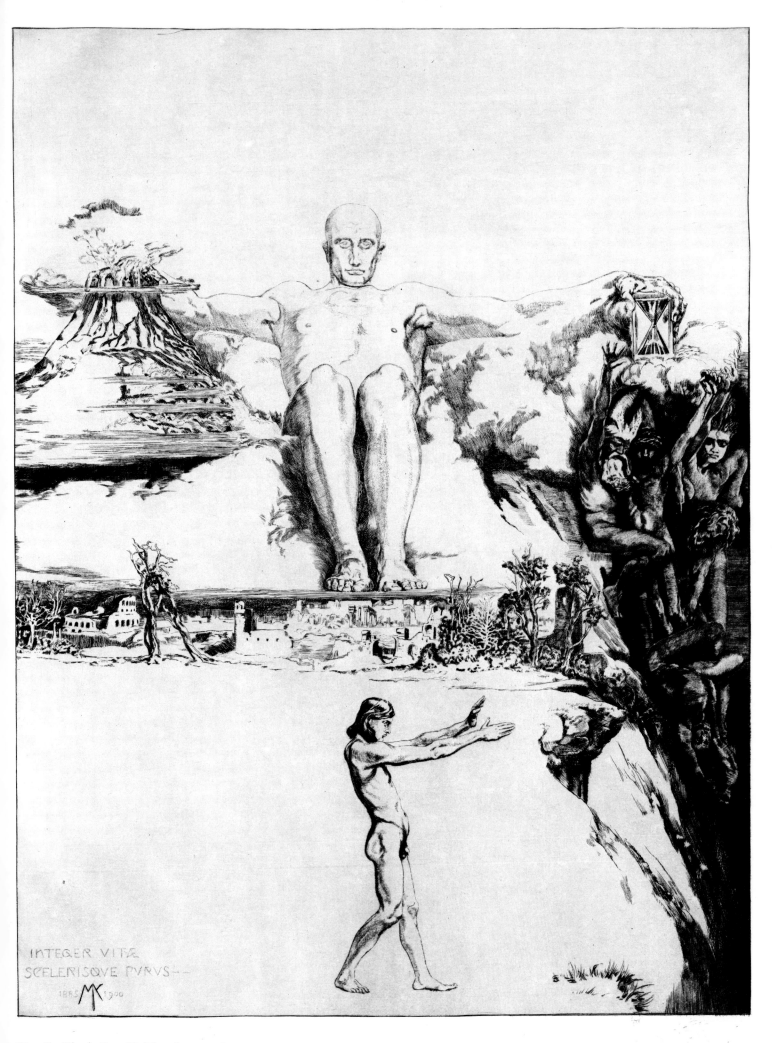

INTEGER VITÆ
SCELERISQVE PVRVS—
1885 MK 1900

71 On Death, Part II: Blameless in Life . . .

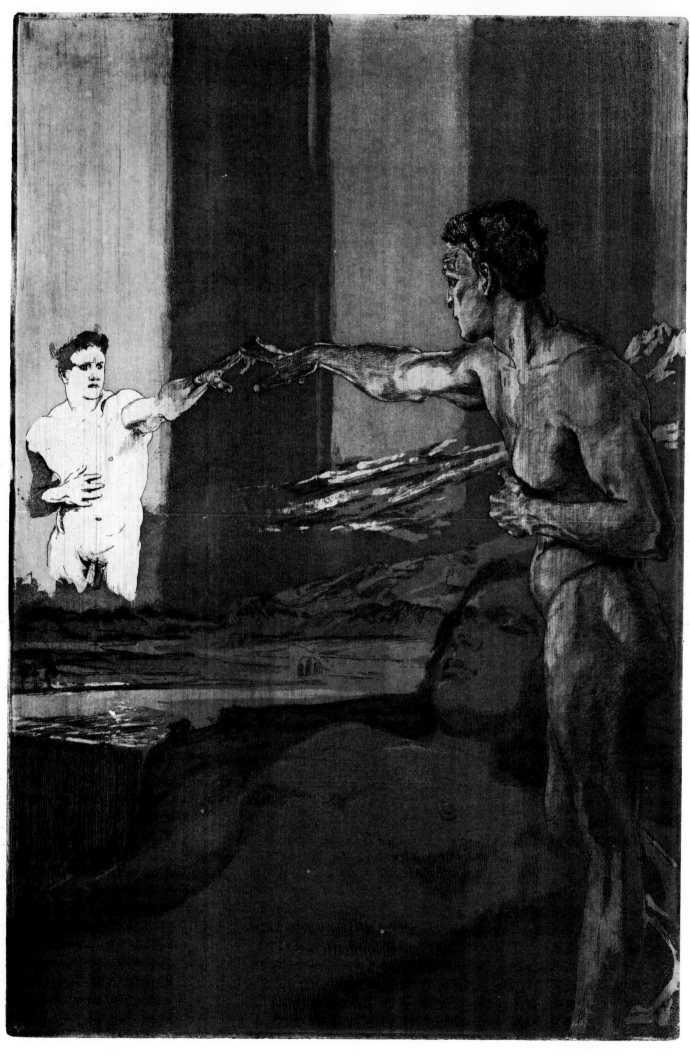

73 On Death, Part II: Plague

Notes on the Plates and Summaries of the Cycles

by J. Kirk T. Varnedoe, with Elizabeth Streicher

The heading for each plate reproduced gives the following information: the title of the plate in English, followed by the German title (when this is not identical with the English) as given in the Singer catalogue (Hans Wolfgang Singer, *Max Klingers Radierungen Stiche und Steindrucke,* Berlin: Amsler und Ruthardt, 1909); the Singer catalogue number (e.g., S.10, S.11, etc.); the medium (etching, or etching and aquatint; see Technical Note); the dimensions of the plate on which the image is drawn; and the dimensions of the image itself. All dimensions are given with height before width, and are given first in centimeters, then in inches.

FRONTISPIECE: The Artist in the Garret (*Der Künstler in der Dachstube*), S.261, etching and aquatint
Plate: 16 x 7.4 cm., 6¼ x 2⅞ in.
Image: 14.6 x 6.1 cm., 5 11/16 x 2⅜ in.
The plate is said by Singer to represent Klinger's friend, the Norwegian painter and novelist Christian Krohg, and to date from Klinger's stay in Brussels in the late 1870s. Krohg and Klinger were fellow students under Karl von Gussow both in Karlsruhe and Berlin, and shared living quarters in the mid-1870s. Krohg was later to be the teacher of Edvard Munch. Bundled up against the cold, with a piece of bread waiting on top of his traveling-bag, the artist stares intently at the canvas on the easel before him. His thoughts may be on the book he has been reading (on the floor, lower right), *Manette Salomon*, a realist novel (1865) by Edmond and Jules de Goncourt. *Manette Salomon* deals with artistic life in Paris, and contains lengthy criticism of contemporary Salon exhibitions, generally echoing the call of the poet Baudelaire for an art depicting the romance of modern civiliza-

tion. This interest in realist literature would seem to be at odds with Klinger's other interests in Brussels. He went there to study with the painter Charles-Emile Wauters, a notorious purveyor of neomedieval horror fantasies.

ETCHED SKETCHES (*Radierte Skizzen*), 1879
8 plates, 2 editions (both 1879)
An apparently unrelated group of fantasy images, in which appear for the first time some of Klinger's recurrent personal images: sinister animals, tantalizing women, societal conflict. Klinger hoped to dedicate these prints to the composer Johannes Brahms, but they were published without a dedication.

1. The Beginning of Spring (*Frühlingsanfang*), S.19, etching and aquatint
Plate: 41.5 x 16.8 cm., 16⅜ x 6⅝ in.
Image: 25.9 x 16.3 cm., 10¼ x 6⅜ in.
A young woman dreamily fondles a flower, as she lies in a field below a stand of bare trees just beginning to sprout buds. The implied unity between human mental life and the cycle of nature is here expressed in a composition whose virtually shadowless flatness testifies to Klinger's study of Japanese woodblock prints.

2. Dying Wanderer (*Sterbender Wanderer*), S.22, etching and aquatint
Plate: 41.4 x 29.7 cm., 16⅝ x 11⅝ in.
Image: 30.6 x 17.4 cm., 12⅛ x 6⅞ in.
In a landscape of rock and ice, an old man, dressed only in a loincloth, leans feebly against a rock. His spear has slipped from his hand, and he is powerless to escape the death prefigured by the intently waiting vulture. This image of nature's implacable, sinister cruelty offers a striking comparison with the lyrical optimism of Plate 1.

RESCUES OF OVIDIAN VICTIMS (*Rettungen Ovidischer Opfer*), 1879

13 plates, 5 editions: 1879, —, 1882, 1891, 1898

A curious reformulation of Ovid's *Metamorphoses,* in which the tragic fates of three pairs of mythological lovers—Pyramus and Thisbe, Narcissus and Echo, and Apollo and Daphne—are changed. Klinger invents new endings for Ovid's stories, often "rescuing" the protagonists only to cast them into disappointing or ambiguous new situations. The plates dealing with the narration are composed with conventional formulae of nineteenth-century classicism, but the interspersed "Intermezzo" images, which bear no relation to the tales, are more obviously Japanese in stylistic inspiration. The cycle is dedicated to the memory of the composer Robert Schumann, and the use of "Intermezzo" plates may be an attempt by the artist to orchestrate this cycle in a musical fashion. Klinger in fact once asserted that he had been influenced by Schumann's working methods.

3. Painterly Dedication/ Invocation (*Malerische Zueignung/ Anrufung*), S.25, etching and aquatint
 Plate: 41.2 x 25.7 cm., 16¾ x 10¼ in.
 Image: 38.6 x 23.5 cm., 15⅛ x 9 3/16 in.

This is the first plate in the cycle. We see the artist's table, covered with etching and drawing tools. As the candles burn into their sockets, his hands clasp in an appeal for inspiration. Above the curling smoke, a landscape appears, with a colossal bust of Ovid in the foreground and, as if in echo of the artist's own invocation, a tiny smoking altar of sacrifice, with a beseeching figure, in the distant background. The fervor of Klinger's nostalgia for the distant classical past is suggested in this fantasy.

4. First Intermezzo (*Erstes Intermezzo*), S.30, etching and aquatint
 Plate: 31.5 x 21.9 cm., 12 7/16 x 8⅝ in.
 Image: 27.6 x 18.9 cm., 10⅞ x 7 7/16 in.

The sixth plate in the cycle, this image of a young woman swinging high in a dark sky provides a note of dream-like playful freedom following Klinger's rather depressing retelling of the story of Pyramus and Thisbe.

EVE AND THE FUTURE (*Eva und die Zukunft*), 1880

6 plates, 6 editions: 1880, 1882, 1891, 1893, 1893, 1898

In contrast to the generally neutral or satirical emotional tenor of Klinger's first two print folios, *Eve and the Future* is a consistently pessimistic personal vision of original sin and its consequences. There are three narrative plates related to the biblical story of the Fall, interspersed with three Futures that, in a fashion premonitory of a movie's "flash-forward" technique, symbolize the evils that Eve's sin will bring into the world. The cycle is dedicated to Klinger's friend Christian Krohg (see note on Frontispiece).

5. Eve (*Eva*), S.43, etching and aquatint
 Plate: 21.2 x 26.2 cm., 8 5/16 x 10 5/16 in.
 Image: 17 x 22.9 cm., 6⅝ x 9 in.

In a densely overgrown landscape, Eve preens herself pensively while Adam sleeps. The tightly detailed vegetation, rendered in a rich variety of strokes, establishes a feeling of lush fertility that contrasts joltingly with the plate immediately following.

6. First Future (*Erste Zukunft*), S.44, etching and aquatint
 Plate: 39.6 x 26.4 cm., 15½ x 11⅜ in.
 Image: 35.8 x 23.2 cm., 14⅛ x 9⅛ in.

At the end of a high-walled rock canyon, blocking the viewer's only escape, waits a malevolent tiger. Klinger apparently intended this to represent the horrible inevitability of death waiting at the end of life's path, mankind's fate as a result of original sin.

7. The Serpent (*Die Schlange*), S.45, etching and aquatint
 Plate: 29.3 x 15.6 cm., 11½ x 6 1/16 in.
 Image: 24.8 x 12 cm., 9¾ x 4 11/16 in.

Eve stands on a high knoll above the rivers of Paradise, before the Tree of Knowledge. As she holds the forbidden apple, the insidious serpent holds up a mirror so that she can admire herself. This extraordinary image specifically identifies Eve's pride, above all her physical vanity, as the root cause of the Fall, and thus of the curse of death.

8. Second Future (*Zweite Zukunft*), S.46, etching and aquatint
 Plate: 29.8 x 26.7 cm., 11 11/16 x 10½ in.
 Image: 26.3 x 22.7 cm., 10⅜ x 8 15/16 in.

Against a calm sky and glassy sea, evoked in even, subtle aquatints, a demon prowls in stealth, atop a strange fish, his harpoon at the ready. Singer states that this is a sea of blood, and that the swimming beast is a leech. As opposed to the waiting tiger of the "First Future," this figure apparently symbolizes death that arrives unexpectedly (according to one of Klinger's biographers). Klinger has scratched in the form of the demon in a mesh of purposefully rough strokes, so that this form stands out with startling sharpness against the smooth ground.

9. Adam, S.47, etching and aquatint
 Plate: 29.5 x 26.8 cm., 11⅝ x 10 9/16 in.
 Image: 25.6 x 24.4 cm., 10 1/16 x 9 9/16 in.

Adam and Eve have been expelled from Paradise, and behind them the angel with the flaming sword blocks the gate. The idea of Adam carrying Eve is a departure from the more familiar depiction of the two walking away together. Here, as in the whole cycle, Klinger seems to assert that woman is weaker, and is primarily to be blamed for the Fall, while man, the stronger and less guilty, must literally bear the burden. This conception of the nature of woman, and of the relationship between the sexes with regard to sin, will be modified in later cycles such as *A Love* and *A Life*.

10. Third Future (*Dritte Zukunft*), S.48, etching
 Plate: 29.7 x 20.2 cm., 11 11/16 x 7⅞ in.
 Image: 18.6 x 12.8 cm., 7¼ x 5 in.

In one of Klinger's most chilling images, this cycle comes to a close with a skeleton (only partially decomposed) relentlessly and gleefully crushing human beings with a pounding device used in road paving. This is a shockingly literal visualization of the idea of the all-leveling power of death, a modernization of the medieval image of the Dance of Death, in which gleeful skeletons marshaled people from all walks of life into a procession to the grave. In the background of this scene, a cross appears, ineffectual, while at the upper right edge, a hand intrudes. According to contemporary descriptions, the original drawing for the scene included Athena and Zeus at the upper right; the hand, gesturing for a halt to the mayhem, is a residual symbol of their presence, and thus raises even more pointedly the issue of Klinger's ambivalent attitude toward Christian tenets. The whole cycle shows his belief in original sin, but this plate asserts his disbelief in the compensating idea of salvation. The pagan gods, in their restraining in-

tervention, seem to offer a humane alternative. The image was apparently composed in 1879, prior to inclusion in this cycle. It was originally inscribed "The Paver after Jean Paul F. R." (Der Pflasterer nach Jean Paul F. R.), and thus attests to Klinger's reading of the works of the early nineteenth-century German romantic writer Johann Paul Friedrich Richter, known as Jean Paul.

INTERMEZZOS (*Intermezzi*), 1881
12 plates, 1 edition

This is not an integrated cycle of plates, but an assemblage of diverse themes, including several plates of centaurs in landscapes and four plates devoted to the baroque novel *Simplicius Simplicissimus*, by H. J. C. von Grimmelshausen (published 1669). The cycle is dedicated to the engraver and art dealer Hermann Sagert, who apparently initiated Klinger in the techniques of etching.

11. Pursued Centaur (*Verfolgter Centaur*), S.54, etching and aquatint
 Plate: 20.9 x 40.6 cm., 8 3/16 x 16 in.
 Image: 16.3 x 37 cm., 6 7/16 x 14 9/16 in.

Klinger is extraordinary in his visualization of mythological scenes in terms of striking realism and emotional immediacy. Here across a windswept field, human hunters pursue a centaur, who has just wounded the lead horse with a desperate bow-shot. No explanation for this cruel violence is evident. The strain of the race across the lower part of the plate is curiously muffled by the enveloping grass and frozen by the vertical punctuation of the horse's agonized scream, held against a point of white in the cloud-streaked sky. This mysterious fragment of an unknown narrative thus takes on a haunting intensity.

12. Battling Centaurs (*Kämpfende Centauren*), S.55, etching and aquatint
 Plate: 41.5 x 26.9 cm., 16⅜ x 10 9/16 in.
 Image: 38.2 x 24.7 cm., 15 1/16 x 9¾ in.

Again, as in the previous image, Klinger injects into classical mythology an unexpected note of sinister reality. In mountains made deathly desolate by winter, two centaurs battle for the meager nourishment of the dead hare to the right. As in "Dying Wanderer" (Plate 2), Klinger's idea of the cruelty of nature is evident, as the peaks rise in icy grandeur undisturbed by the mortal struggle below. One should perhaps remember the important intellectual power of Darwin's image of the eternal natural struggle

as it affected thinkers of Klinger's time. The aquatinting of the sky is especially rich here.

13. Simplicius at the Hermit's Grave (*Simplicius am Grabe des Einsiedlers*), S.59, etching
 Plate: 33.7 x 26.6 cm., 13¼ x 10½ in.
 Image: 29.3 x 22.9 cm., 11½ x 9 in.

In Grimmelshausen's story, the young boy Simplicius takes refuge in the forest with a hermit during the Thirty Years' War. In this scene, the benevolent hermit has died, leaving the boy to prepare his return to a war-torn civilization. Here, as in all the Simplicius prints, Klinger depicts a gnarled, specifically German woodland.

14. Fallen Rider (*Gefallener Reiter*), S.62, etching
 Plate: 36.8 x 23.6 cm., 14½ x 9 1/16 in.
 Image: 32.3 x 19.5 cm., 12¾ x 11/16 in.

A horse has fallen in the woods, and is dying with his rider's leg trapped beneath him. The rider has lost his sword in the fall, and cannot reach it. Sensing death, a flock of ravens gather, only to be dispersed by a wolf, who claims the trapped prey for himself. The onset of unavoidable, lonely death, already imaged in Plate 2, is here all the more fearful for being the result of a capricious accident; this is an anxiety Klinger will take up again in *On Death, Part I*.

15. Cupid, Death and the Beyond (*Amor, Tod und Jenseits*), S.63, etching and aquatint
 Plate: 20 x 42.6 cm., 7⅞ x 16 13/16 in.
 Image: 15.7 x 41 cm., 6 3/16 x 16⅛ in.

In an empty landscape, Klinger stages a race between three forces that torment the thoughts of men. Leading, on a winged wheel, is Cupid, or Love, with his bow and arrow. Fast behind comes Death on a coffin stallion, which he goads with a sickle whip. In last place is the vague, far less tangible composite image of the Beyond, or Life after Death. This shrouded, feather-decked ghost rides a horned animal which moves forward on multiple tiny hands. The image, composed when Klinger was 23, as a whole seems an analogy of the young artist's mental life: moved strongly by eroticism, always conscious of pursuing death, and uncertain as to the nature of any eventual existence beyond the grave.

CUPID AND PSYCHE (*Amor und Psyche*), 1880
46 plates, 1 edition

This is the only one of Klinger's print cycles that illustrates literally a specific text: the fable of the love of Cupid for Psyche, the youngest daughter of a king. The tale, by Apuleius, is one of jealousy, clandestine love, false suspicions with tragic consequences, and final happiness only after long frustration. Klinger conceived the illustrations in two folios. The plates of the first folio, such as the two selected here, are large and ornate, while those of the second folio, often grouped several to a page, are smaller vignettes, bearing a kind of parenthetical relationship to the development of major scenes in the larger plates. Klinger later remarked how frustrated he had been to be tied down to a specific text, and cited this cycle as the determining factor in his decision never again to undertake direct illustrations.

16. Psyche on the Cliff (*Psyche auf dem Felsen*), S.73, etching and aquatint
 Plate: 36.7 x 26.7 cm., 14½ x 10½ in.
 Image: 25.5 x 17.3 cm., 10 1/16 x 6 13/16 in.

In the central image, Klinger conveys different senses of volume, density and texture by varying strictly controlled patterns of line. Against this rich field, the deep grey of the aquatinted sea and the pure white sliver of the waning moon are particularly effective. One of the most interesting parts of the print is its border, where two skulls (lower right and left, apparently skulls of goats or gazelles) and a variety of plant life are woven together in a constantly moving ornamental band, set against an open lattice of cross-hatching. Klinger starts with a decorative vocabulary based on Hellenistic and Roman ornamental patterns, but transforms these conventions into a more energetic and complex design, only distantly related to the antique sources and somewhat opposed to the neoclassical calm of the figure of Psyche within. This process of personal extrapolation of inherited motifs, pushed much further in Plate 17, prefigures the kind of inventive margin that will be the hallmark of *On Death, Part I*.

17. Psyche with the Lamp (*Psyche mit der Lampe*), S.82, etching and aquatint
 Plate: 36.6 x 27.6 cm., 14 7/16 x 10⅞ in.
 Image: 25.6 x 17.5 cm., 10 1/16 x 6⅞ in.

Cupid met Psyche only by night, and thus she never clearly saw his face. Psyche's sisters tried to persuade her that her night-vis-

iting lover was a monster, and she was compelled by curiosity to light a lamp in order to examine his features. The lamp's light, which is the central feature of this image, showed Cupid's divine beauty; but spilled hot lamp oil then caused Cupid to awaken and vanish, and much of the rest of the tale deals with Psyche's long and arduous search to find him again. Here Klinger seems to establish a more direct linkage between the image and its prominent decorative border than in Plate 16. The lamp-lit face is an obvious connection. More subtly, the almost suffocating fullness of the rose garland reinforces the idea of a protected bower, at the full-bloom moment of Psyche's happiness. The bursting vegetative energy of the border adds an emotional dimension to the simply stated scene within.

A GLOVE (*Ein Handschuh*), 1881
10 plates, 5 editions: 1881, 1882, 1893, 1898,—

This cycle is also known by the title given the second edition: "Paraphrase on the Finding of a Glove." The story begins with the artist himself at a roller-skating rink in Berlin. He picks up a glove dropped by an attractive woman. When he takes the glove home that evening, a series of bizarre fantasies ensue. The glove, alternately active and passive, small and gigantesque, is pursued, abducted and enshrined, in a dream-cum-nightmare the specific meaning of which never has been, nor perhaps ever can be, satisfactorily explained. Though the prints were published in 1881, the images were conceived much earlier. In April of 1878, Klinger exhibited the ten compositions as a suite of ink drawings at the Art Union in Berlin. The exhibition immediately established a name for the artist. The etchings, which differ from the original drawings only slightly, have remained the best known and most admired of his graphic works. They are not as technically rich as some plates from later cycles, but for sheer strangeness, condensed visual impact and premonitory modernity, they remain his most astounding images.

18. Place (*Ort*), S.113, etching and aquatint
 Plate: 25.7 x 34.7 cm., 11⅛ x 13 11/16 in.
 Image: 22.8 x 32.7 cm., 9 x 12⅞ in.
The scene is an open-air roller-skating rink in Berlin; we are looking at a wall of windows, above which a tent-roof extends. Klinger, with a dark beard and striped trousers, stands next to his friend Prell on the left. Their glances, and those of several other people in the scene, are drawn to a lady who skates in on the right, between two men who doff their hats to her. She apparently represents a Brazilian woman who was a famous beauty one season in the Berlin of Klinger's youth. The frieze-like composition, dominated by the rectangles of the severe architecture, seems initially quite static. However, this sense of banal stiffness is countered by the electric patterns of reflection in the windows, and by the jarringly instantaneous punctuation of the little girl's still-unfinished pratfall.

19. Action (*Handlung*), S.114, etching
 Plate: 29.9 x 21 cm., 11¾ x 8¼ in.
 Image: 24.8 x 18.9 cm., 9¾ x 7 7/16 in.
On the terrace of the rink, seen against a nearby woods, two men and a woman skate away together to the upper left, while in the middle distance a lone woman glides directly away from us, having dropped a glove behind her. This is apparently the same Brazilian beauty seen entering in "Place," though she is in different dress. From the right the artist lunges in to retrieve the glove. The dream-like sway of the other skating figures offsets the notes of sudden movement given by Klinger's impulsive gesture and by the scurrying dog. The instant takes on a sense of oddly pregnant suspension.

20. Yearnings (*Wünsche*), S.115, etching and aquatint
 Plate: 31.5 x 13.8 cm., 12⅜ x 5 7/16 in.
 Image: 28 x 10.7 cm., 11 x 4 3/16 in.
The artist sits in bed, his face buried in his hands against his knees. The glove lies on the blanket before him, while in the background a vision of landscape appears: a nearby fruit tree, and then, far behind, a mountain rising half in shadow, half in light. On the mountain, a small woods sprawls in a curiously biomorphic shape, while on the road below stands the tiny figure of a woman—perhaps the dream-presence of the glove's rightful owner.

21. Rescue (*Rettung*), S.116, etching
 Plate: 23.6 x 18.2 cm., 9 5/16 x 7⅛ in.
 Image: 14.3 x 10.4 cm., 5⅝ x 4 1/16 in.
The glove sinks in a stormy sea, while the artist, incongruously dressed in his nightshirt and hat, pursues it in a sailboat and attempts to snare it with a long boat hook.

22. Triumph, S.117, etching
 Plate: 14.5 x 26.8 cm., 5 11/16 x 10½ in.

Image: 11 x 23.8 cm., 4 5/16 x 9⅜ in.

The glove rides in an odd bivalve chariot, reining in the two white horses that pull it through a glassy sea. Behind, the sun sits on the horizon, perhaps indicating the dawn following the stormy night of Plate 21. The pure whiteness of this print, its precise linearity and its elaborate stylizations set it strongly apart from the previous images. The style owes a great deal to the devices of neoclassical illustration, but the complex curves also suggest a premonition of the Art Nouveau style that dominated much of European art and design in the later 1880s and 1890s. This is particularly true of the whiplash decorative motifs at the bottom, the curls of which, part plant and part wave, conceal a frolicking reptilian creature.

23. Homage (*Huldigung*), S.118, etching
 Plate: 15.9 x 32.8 cm., 6¼ x 12 15/16 in.
 Image: 12.3 x 29.2 cm., 4 13/16 x 11½ in.

By moonlight the sea worships the glove. Placed on a rock between two oil lamps at the left, the glove accepts passively an inundation of roses that apparently spring spontaneously from the waves rolling in to lie at the foot of the rock.

24. Anxieties (*Ängste*), S.119, etching
 Plate: 14.4 x 26.9 cm., 5⅝ x 10 9/16 in.
 Image: 11 x 23.9 cm., 4 5/16 x 9⅜ in.

Klinger, in bed, huddles against the wall, clutching his pillow with both hands. Behind him a giant glove looms, partially blocking an eclipsed moon, in a black sky that the glove's fingers seem almost to grasp at its right edge. By the light of a single smoking candle in the lower center, a host of creatures are borne in on the surging waves that swirl over the bed's edge. In the group are two long-snouted, menacing fantasy animals, one of which carries a long-haired humanoid on its folded bat-like wings. One of the tormentors calls to Klinger, as he points simultaneously to the large glove behind and to two other gloves, or gloved hands, in the tide on the left.

25. Repose (*Ruhe*), S.120, etching
 Plate: 14.3 x 26.8 cm., 5⅝ x 10½ in.
 Image: 11.1 x 23.4 cm., 4⅜ x 9¼ in.

The glove rests on a wrought-iron stand in the center of an empty floor, with decorative garlands suspended on either edge of the image. Behind the glove is a curtain made of larger gloves suspended from a rod. There is a strict decorative regularity in the alternating palm views and back views. Left-handed gloves are seen palm forward on the left, right-handed gloves palm forward on the right. The pattern is broken only in the center, where three gloves hung backward offset the table, and at the lower left, where the snout and flipper-like appendage of an animal—apparently the same kind of beast seen in "Anxieties"—intrude. The severe, static quality of this bare linear composition echoes the idea of repose and relates the image to "Triumph."

26. Abduction (*Entführung*), S.121, etching and aquatint
 Plate: 12 x 26.9 cm., 4 11/16 x 10 9/16 in.
 Image: 8.9 x 21.9 cm., 3½ x 8 9/16

This stark nocturnal drama of violent motion is completely jarring after "Repose." Two arms crash through the window at the left (pieces of glass still fall below), reaching in vain for the tail of the creature, which is now seen as a combination of alligator and bat, resembling a prehistoric pterodactyl. The beast flies away into the night with the glove between its jaws. The vision is clear, but eternally perplexing. The beast cannot have flown through the closed window, and the breakage is too small to have been caused by the escaping beast. It seems that the arms, hopelessly locked in maximum extension, have broken the window several moments before, though the beast, in full extended flight, has barely moved away. Time is radically disrupted, and a strongly contradictory mood results from the white blossoms that well up from below the bottom edge.

27. Cupid (*Amor*), S.122, etching
 Plate: 14.2 x 26.7 cm., 5 9/16 x 10½ in.
 Image: 11 x 23.8 cm., 4 5/16 x 9⅜ in.

On a tabletop (?), the glove has come to rest under two pendulous rose branches. Sitting on the far edge, Cupid looks back over his shoulder with an expression whose emotion cannot be discerned; his traditional bow and quiver, with three arrows, lie on the near left. We are uncertain whether the glove is dead or at rest, or whether Cupid mourns or surveys protectively. On this ambiguous note, the ten-part fantasy closes.

Postscript to A Glove: According to a review by a critic close to Klinger, the original drawings for *A Glove* were in a different sequence when shown at the Art Union in Berlin in 1878. To regain that described order, we would place the numbered plates above in the sequence: 18, 19, 24, 27, 21, 22, 26, 25, 23 (Plate 20, "Yearnings," is not described in the review). Also, in an early

proof edition of *A Glove* now owned by the Carus Gallery, New York City, Klinger added pencil annotations that often change the titles given by Singer. "Place," Plate 18, is given the French title "Préambule I," and "Action," Plate 19, is given both the German title "Sachverhalt" (meaning "the state of things" or "the facts of the case") and the French title "Préambule II." Plate 21, "Rescue," is given the German title "Die Gefahr" (The Danger) and the French title "En Péril" (In Danger). Plate 22, "Triumph," is entitled "Gerettet" and "Sauvé," both meaning "rescued." Plate 24, "Anxieties," is given the German title "Alp" (Nightmare), while Plate 26,"Abduction," is entitled "Traumes Ende" and "Fin de rêve," both meaning "the end of the dream." Finally, Plate 27, "Cupid," is given the title "Beim Erwachen" and "Au Réveil," meaning "on awakening." Perhaps, however, all attempts to fix exact descriptive titles, or to arrange a continuous narrative in the last eight plates of the cycle, must inevitably founder. The sequence, in whatever order and by whatever titles, seems purposefully disjunctive, and the questions one image raises find no answer in any other. Alternating between peace and violence, day and night, security and anxiety, *A Glove* gains part of its insoluble mystery by constantly implying a larger story than we can ever know.

FOUR LANDSCAPES (Vier Landschaften), 1883
4 plates, 3 editions (all 1883)

There is no apparent unity to this group of four scenes of the countryside around Leipzig, save that all show prominent architecture or other human reshaping of the landscape. The three not shown here are concerned with specific times of day or seasons, "Noon," "Moonlight Night" and "Summer Afternoon," but there appears to be no intention to construct a traditional Four Seasons or Four Times of Day pattern.

28. The Road (*Die Chaussee*), S.124, etching and aquatint
 Plate: 52.6 x 36.7 cm., 20¾ x 14 7/16 in.
 Image: 47.5 x 33.5 cm., 18¾ x 13 3/16 in.

Though the other three plates in the folio are relatively banal and placid, this scene is powerfully evocative. The perspectives of the fence and trees on either side rush to convergence with an unchecked urgency. It is the kind of funneling space found in the psychologically charged vision of Van Gogh,

for example, here rendered with a crisp, cool realism that makes it perhaps even more disturbing. The young trees at the right are bound by wire to wooden stake-poles; hence their regimented regularity, and also a certain undercurrent of latent tension, echoed in the ominously leaden sky. In this technically rich plate, the aquatinted sky is particularly striking. It descends slowly from an even light grey at the top of the plate to a deep, bass note, darkest and most sinister at the point where the road hurtles into deep space. This same scene, modified, appears in *On Death, Part I* (Plate 59).

A LIFE (*Ein Leben*), 1884
15 plates, 4 editions: 1884, (1884), 1891, 1898

A moralizing tale of sin and suffering, set in the society of the 1880s, *A Life* follows the fate of a woman abandoned by her lover, ostracized by society and forced to turn to prostitution. The cycle opens with an image of Eve, accompanied by an adaptation of the biblical passage: "And the serpent said unto the woman, Ye shall not surely die: For God doth know that in the day ye eat thereof, then your eyes shall be opened, and ye shall be as gods, knowing good and evil" (Genesis 3: 4, 5). The cycle closes with images of the afterlife, as Klinger attempts to link contemporary tragedy and corruption to traditional religious structures of understanding the relationship of men to women, and sin to death.

29. Dreams (*Träume*), S.129, etching
 Plate: 30.3 x 17.7 cm., 11 15/16 x 6 15/16 in.
 Image: 25.4 x 14.1 cm., 10 x 5½ in.

A wide-eyed young woman sits up in bed, tormented by creatures of her imagination. The horrid demons recall Goya and prefigure Ensor, while the relatively benign, sleeping face directly above her head—literally "on her mind"—may be that of her absent lover.

30. Seduction (*Verführung*), S.130, etching and aquatint
 Plate: 30.3 x 17.7 cm., 11 15/16 x 6 15/16 in.
 Image: 25.4 x 14.1 cm., 10 x 5½ in.

In a bizarre immersion fantasy of bliss, Klinger shows two naked lovers embracing under the sea, riding astride improbable fish-like creatures.

31. Abandoned (*Verlassen*), S.131, etching and aquatint
 Plate: 31.5 x 44.7 cm., 12 7/16 x

17⅝ in.
Image: 27.1 x 41.7 cm., 10⅝ x 16 7/16 in.

At the edge of the sea, a distraught woman walks, clutching her face. The lover who filled her thoughts and seduced her, in Plates 29 and 30, has now abandoned her. The seaside setting is indebted to the German romantic landscape tradition (see Introduction, Fig. 3). However, the aura of expressive anguish, sensed in the uncharacteristically loose, racing strokes of the rendering, and especially in the shrill rust-orange ink in which this plate is usually printed, are strikingly modern. Nature seems to echo this woman's psychic distress, especially in the menacing fist-cloud, whose taut clinch on the horizon restates her desperate withdrawal into herself on the empty shore.

32. For All (*Für Alle*), S.134, etching
Plate: 28.4 x 20.2 cm., 11 3/16 x 7 15/16 in.
Image: 21.5 x 17 cm., 8 7/16 x 6 11/16 in.

Left to fend for herself, the woman dances for a living. Though this may seem innocent, we must remember that it was a common idea in Klinger's time that dancers supplemented their incomes by prostitution (the plate following this one in the cycle shows the woman on the street in prostitute's garb, confirming these implications). Hence the combination of the print's title and the sexually suggestive nature of the pirouette before the crowd stress this moment in the limelight as a step into the darkness of degradation.

33. Into the Gutter! (*In die Gosse!*), S.136, etching and aquatint
Plate: 20.8 x 19 cm., 8⅛ x 7 7/16 in.
Image: 18.7 x 16.8 cm., 7⅜ x 6 9/16 in.

The struggling woman is pushed by a sordid crowd toward a gutter into which a sewer pours. On the left, an old woman sweeps her along like trash, while on the right a rotund monk assists. The woman's white dress is a startling contrast with the shadowy darkness, and the overall tonal structure suggests the drama of etchings by Goya. The white dress, furthermore, is a traditional symbol of purity, and it would seem that Klinger purposely uses it to assert the woman's blamelessness. A corrupt and hypocritical society, here particularly the lower classes and the church, literally push her to her ruin.

34. Caught (*Gefesselt*), S.137, etching and aquatint
Plate: 29.1 x 20.5 cm., 11 7/16 x 8 1/16 in.
Image: 26.7 x 18.7 cm., 10½ x 7⅜ in.

Out of the water, a huge vampire bat bears aloft the woman's nude body, to be inspected by a nocturnal crowd in elegant evening attire. One of the men at the left doffs his hat sarcastically at the pitiful display, while another, just to the right of him, leans closer to peer through hand-held spectacles. The bitter social message of the cycle is evident here: the poor (Plate 33) are hypocritically moral, while these rich are simply heartless. Having drained the woman's life blood through exploitation (hence the vampire?), they are now entertained by the spectacle of her helpless shame.

35. Going Under (*Untergang*), S.138, etching and aquatint
Plate: 27.3 x 22.6 cm., 10¾ x 8⅞ in.
Image: 24.5 x 19.7 cm., 9½ x 7¾ in.

In this morbidly literal image of final desperation, Klinger seems to make a visual-verbal association. The title "Untergang" means literally "going under," but more commonly downfall, ruin or destruction. The plate thus symbolizes directly the woman's downfall into death. It is an ironic symbolization, since her blissful seduction in Plate 30 was imaged in terms of submersion as well.

36. Suffer! (*Leide!*), S.140, etching and aquatint
Plate: 29.2 x 20.7 cm., 11½ x 8⅛ in.
Image: 27.2 x 16.4 cm., 10 3/16 x 6⅜ in.

This visionary crucifixion, so suggestive of the effects of Hollywood or of surrealism (see Dali, Fig. 14 in Introduction), is ambiguous in import. The crucified Christ should suggest the concept of salvation for sinners. However, the woman turns away grieving from the vision, while only her unidentified companion looks back. The word "Leide!" is emblazoned on the top of the cross.

37. Back into Nothingness (*Ins Nichts zurück*), S.141, etching and aquatint
Plate: 29.3 x 24.7 cm., 11½ x 9 11/16 in.
Image: 26 x 20.6 cm., 10 3/16 x 8⅛ in.

The woman's long hair, by which she was suspended over the abyss, has just been severed by the sweep of a great scythe blade. In the blackness below, a huge winged man reaches up impassively to catch the plummeting figure. This is the last plate of the cycle, and the final message of *A Life* would seem thus to be one of pessimism, or nihilism: flesh is weak, love is treacherous, society is unjust and hypocritical, and there is no relief in the harsh demands of Christianity. At

the end of the misery waits only the calming void of nothingness.

DRAMAS (*Dramen*), 1883
10 plates, 5 editions: 1883, (1883), (1883), 1883, —

Klinger's critique of late nineteenth-century society, begun in *A Life,* reaches its high-water mark in the *Dramas,* a series of six episodes from contemporary life. According to Klinger's later letters, the cycle was based on his infatuation with French realist novels by Flaubert, Zola and the Goncourt brothers. In fact, Klinger stated that he originally wanted to dedicate the cycle to Zola (the cycle was finally dedicated to his teacher Karl von Gussow). Klinger apparently based some of the episodes on stories found in daily newspapers. In imitation of Zola's so-called "scientific" realism, he scrupulously researched every detail of his scenes. No biblical or mythological allusions, nor any traditional allegorical or symbolic devices, intrude on this documentation of crime, social disorder, tragedy and death. Several themes on which Klinger focuses—adultery, prostitution and the destruction of families by poverty and drunkenness—relate specifically to the societal oppression of women, a prominent contemporary concern, particularly in realist novels. In a large sense, especially with its three scenes of revolution and one of a street murder, the *Dramas* are concerned with the woeful effects of the modern urban environment, another point of widespread debate in the 1880s. Such a pointedly political critique offers a polar contrast to the mythological dreams of *Rescues of Ovidian Victims* and *Cupid and Psyche,* and to the wholly atemporal, self-indulgent fantasies of *A Glove.*

38. In Flagranti, S.147, etching
Plate: 46 x 32 cm., 19⅛ x 12⅝ in.
Image: 41.9 x 25 cm., 16 7/16 x 9 13/16 in.

The Latin title, related to the traditional phrase *flagrante delicto,* means "caught in the act." The act here was one of adultery, a woman meeting with her lover on a moonlit terrace. Her husband, leaning out of the upstairs window, has just shot the lover, whose feet sprawl out from behind the balustrade. The report of the shot still seems to hang in the air, as the birds swirl away in fright and the woman clutches her ears in horror.

The terror of the scene is intensified by Klinger's understatement: the moment of maximum violence has just passed, the agony of the dead man is only hinted at, and the whole scene is slowed to an eerie suspension by the obsessive detailing of the ornate villa and the dense plant growth. Giorgio de Chirico (see Introduction) remarked that the image "possesses the dramatic sense of certain moments in the cinema in which people inhabiting tragedy and modern life appear frozen in the spectrality of a moment, scenes that are terrible and real."

39. A Mother I (*Eine Mutter I*), S.149, etching and aquatint
Plate: 46 x 32 cm., 18 1/16 x 12 9/16 in.
Image: 42 x 25.8 cm., 16½ x 10⅛ in.

A Mother is a cycle-within-a-cycle, based on a story drawn from a published account of court proceedings. Three numbered plates summarize the case of a woman who, in despair, attempted to drown both herself and her young son. Klinger related the published story on the title page of the fifth edition. In this first scene, we look down into the narrow back court of a lower-class apartment building in a poor section of Berlin. In an elevated walkway, a woman struggles under a load of laundry. On a narrow balcony at the right, two women restrain a drunken father from beating with a stick his wife and child, huddled in fear against the wall.

40. A Mother II (*Eine Mutter II*), S.150, etching and aquatint
Plate: 45.9 x 31.9 cm., 18 1/16 x 12 9/16 in.
Image: 41.8 x 28.1 cm., 16 1/16 x 11 1/16 in.

The scene is set by a bridge in Berlin. The mother has tried to end her misery and that of her son by drowning. The boy is dead and lies on the small dock, but the mother has been saved. She stands, with head bowed, at the top of the stairs. Police try to control the crowd that presses toward her. On the neoclassical building facade in the background, one can read fragments of inscriptions: "[Bil?]der-Academie" (Picture Academy), ". . . oss" and "Deusche [Deutsche] Kunst" (German Art). Perhaps by placing an art academy literally in the background, standing placidly at a distance from this human drama, Klinger implies a critique of the tradition-based official art instruction that does not concern itself with social problems of contemporary society.

41. A Mother III (*Eine Mutter III*), S.151, etching
Plate: 45.8 x 35.8 cm., 18 1/16 x 14 1/16 in.

Image: 41.6 x 32 cm., 16⅜ x 12 9/16 in.

The mother's story ends with her seated (at lower left, under the round lamp) near a tribunal that must rule on her guilt in the death of her son and attempted suicide. The vast gloom is punctuated by a row of low-hanging lamps, which recede toward the judge standing to speak. The other four judges lend varying degrees of attention, while a scribe works with his back to us. High on the dark back wall, we can barely read the inscribed dictum: "Fürchte Gott" (Fear God). Though the mood is grim, Klinger confirmed in his written recounting of the actual trial that the mother was set free. The ideas evoked here—of justifiable crime in the face of the crushing pressures of capitalism and the city—were current among social thinkers, and in Russian, French and German novels of the time.

42. In the Woods (Im Walde), S.152, etching
Plate: 45.7 x 31.7 cm., 18 x 12½ in.
Image: 41.3 x 27.7 cm., 16½ x 10 15/16 in.

By a path in a sun-speckled glade lies a folded coat, with a note prominently displayed on top; a derby hat has rolled into the path. Though it is perhaps not immediately obvious to us, this image, as confirmed by all Klinger's contemporary biographers, deals with a suicide. Mute objects suggest the larger story, in a technique of exposition frequently used by realist writers and artists. The tranquility of nature, evoked in the beautiful patterns of softened light produced by cross-hatching in the trees, stands as a contrast to the harsh violence of the city, particularly in the March Days series that follows.

43. March Days I (Märztage I), S.154, etching and aquatint
Plate: 46 x 35.7 cm., 18⅛ x 14 in.
Image: 42.8 x 32.9 cm., 16⅞ x 13 in.

Like A Mother, the March Days are three related plates. The subject is urban revolution, and many of Klinger's critics have assumed that the revolution is that of March 1848. In a letter, however, Klinger explained that these were not scenes of the past. They were instead visions of a possible future event, born out of the intense political discussions about radical social democracy that were in the air and in the newspapers in the Berlin of the early 1880s. In the first scene, the trouble begins with a long daytime demonstration in a Berlin square next to the river. Klinger has included details of specific modernity, such as the telephone wires overhead and the iron sign of the Parfümerie Joop on the roof at the upper right (this sign was a familiar landmark near a café Klinger frequented). The building on the right is the Bade-Anstalt (bathing establishment) that stood near the Jannowitz Bridge. The background buildings, however, including the ornate bourgeois house (hotel?) that is apparently being sacked and looted, are invented. The crowd surges as a mass, densely packed into a suffocating tangle of unrest. In the foreground, Klinger shows the crowd's fluctuating emotions: exuberant camaraderie in the embrace on the left and angry struggle in the scuffle on the right.

44. March Days II (Märztage II), S.155, etching and aquatint
Plate: 45.7 x 35.7 cm., 18 1/16 x 14⅛ in.
Image: 43.8 x 33.8 cm., 17¼ x 13 5/16 in.

The revolution is now a full armed battle by night in a different section of Berlin. Behind a meager barricade, the rebels fall and die under withering fire from the forces of order, unseen across an open space filled with smoke. One man stands, frozen in terror, by a column plastered with posters. Klinger was careful to include recognizable contemporary advertisements among the posters, again to underline the specifically modern context.

45. March Days III (Märztage III), S.156, etching and aquatint
Plate: 45.3 x 31.9 cm., 18 x 12⅝ in.
Image: 41.9 x 29.1 cm., 17½ x 11½ in.

The revolution having failed, the captured rebels are herded by soldiers along a moonlit road (possibly toward Spandau prison, in the countryside near Berlin), and once again the tranquil beauty of landscape comes as a calm alternative after the overheated violence of the town. The time of year, suggested in the wet ground and budding trees, is quite specific. Klinger said that he chose the title for the March Days in response to the popular idea that early spring, in particular March, was the moment of change and overthrow, both in nature and in political affairs.

A LOVE (Eine Liebe), 1887
10 plates, 4 editions: 1887, 1903, 1903, —
In A Love, Klinger returns to the plight of the modern woman. Here, in contrast to A Life, the drama centers on a well-to-do woman. She falls in love, has an affair and becomes pregnant. Tormented by shame, she eventually dies in childbirth. The story is an individual's tragedy in which, in comparison to A Life, society is indicted less directly. Once

again, as in *A Life* but in contrast to the *Dramas,* Klinger conceives the story in relation to eternal, specifically religious ideas of sin and retribution.

46. Dedication (*Widmung*), S.157, etching and engraving
Plate: 45.3 x 34.9 cm., 17 13/16 x 13 9/16 in.
Image: 42.1 x 32 cm., 16 9/16 x 12 5/8 in.

The cycle is dedicated to the then highly successful and respected older German Swiss painter Arnold Böcklin (1827–1901), whom Klinger greatly admired. Klinger and Böcklin shared a nostalgia for the classical world, though both frequently depicted that world in unsettlingly unorthodox terms (the realist views of centaurs in Plates 11 and 12, for example, are quite close to Böcklin). Klinger also appreciated Böcklin's moody landscapes, and copied several of them in etchings. The central motif here, of one of the Nornen (goddesses of fate) teaching a young boy to shoot an arrow, may refer to Klinger's learning from Böcklin's example; the female nudes strongly recall Böcklin's Germanic—one might say Wagnerian—brand of idealization.

47. First Encounter (*Erste Begegnung*), S. 158, etching, engraving and aquatint
Plate: 44.5 x 26.5 cm., 17½ x 10 7/16 in.
Image: 40.5 x 23.5 cm., 16 x 9¼ in.

A woman sits in an open carriage on a road in the park. Admiring the rose she holds, she is unaware of being observed by a man who stands some distance behind. This narrative content is almost crowded out of the image by Klinger's obsessive detailing of enclosing masses of trees and bushes: rosebushes in the foreground, and a huge blooming chestnut around the man's head. It is as if the teeming border of Plate 17 had invaded the central image.

48. At the Gate (*Am Thor*), S.159, etching and engraving
Plate: 45.3 x 31.1 cm., 17 13/16 x 12¼ in.
Image: 40.5 x 26.5 cm., 16 x 10 7/16 in.

The same man and woman reappear at an elaborately decorated iron gate. As the woman steps from the gate, her admirer clasps her hand with both of his and kisses it. The man's rush into the scene from the left recalls, especially in the fall of the hat, the similarly impulsive lunge for the glove in "Action," Plate 19.

49. In the Park (*Im Park*), S.160, etching and engraving
Plate: 45.2 x 27.2 cm., 17 13/16 x 10 11/16 in.
Image: 41 x 24.4 cm., 16 3/16 x 9 5/8 in.

In a secluded part of a park, the lovers embrace passionately by a balustrade. At the lower right, we glimpse a small stream and an empty boat with a paddle.

50. Happiness (*Glück*), S.161, etching, engraving and aquatint
Plate: 45.1 x 31.1 cm., 17¾ x 12¼ in.
Image: 41 x 27.5 cm., 16 3/16 x 10 7/8 in.

The newfound love has been consummated. As the man sits on the edge of the bed, the couple embrace tenderly in the flood of moonlight Klinger evokes with a variety of subtly aquatinted highlights. The extraordinary size of the window allows the interior space to merge with the lush gardens beyond, ornamented by a white colonnade around a lake.

51. Intermezzo, S.162, etching and engraving
Plate: 24.5 x 45.5 cm., 9 11/16 x 18 in.
Image: 18.7 x 41.6 cm., 7 3/8 x 16 3/8 in.

After the crescendo of the optimistically orchestrated opening love theme, "Intermezzo" intrudes with a jolting note of horror. The inscription below reads: "Motto: Illico post coitum cachinnus auditur diaboli./ Intermezzo/ Adam und Eva und Tod und Teufel" (Motto: Just after coitus the cackling of the devil is heard./ Intermezzo/ Adam and Eve and Death and Devil). On a rocky shore, Adam and Eve kneel naked before Death, who points at them, and the Devil, who holds a sealed scroll. A serpent lurks at the lower right. Though the composition is apparently original, the message is both traditional and typical of late nineteenth-century anxieties: the pleasures of physical love and the fear of death are closely related in psychic life. Sinful indulgence in bodily pleasures, Klinger asserts, heightens anxiety over the fate of the soul. This plate was conceived prior to the rest of the cycle. Originally, the Latin motto (taken from Schopenhauer) was inscribed beneath the drawing for "Happiness," No. 50.

52. New Dreams of Happiness (*Neue Träume von Glück*), S.163, etching and engraving
Plate: 45.3 x 35 cm., 17 13/16 x 13¾ in.
Image: 41.4 x 31.4 cm., 16¼ x 12 5/16 in.

Following the premonitory pessimism of "Intermezzo," the cycle apparently regains

its optimistic tenor. The couple soars through the night sky on a large drape pulled by a winged boy (Cupid?), who holds a large round mirror. Indeed, it is toward the mirror that the man flies, apparently drawn on by his own reflection. Remembering the criticism of feminine vanity implicit in the image of Eve with the mirror in Plate 7, we note that Klinger now seems to indict masculine self-concern in this ill-fated flight. The woman is lost in blissful contemplation of the man's face, as his fascination with the mirror pulls her aloft to her eventual downfall.

53. Awakening (*Erwachen*), S.164, etching and engraving
Plate: 45.4 x 31.3 cm., 17⅞ x 12¼ in.
Image: 40.4 x 28.4 cm., 15 15/16 x 11 3/16 in.

The woman sits alone on her bed at night, staring into space, her hands rigidly grasping her knees. The window of her room is narrowed (compare "Happiness," Plate 50), and a relatively barren hill appears beyond. Opposite her, on the glass of the opened window, an image shines like the reflection of a light in the night outside. The image is, in a mandorla-like field of white, the small naked form of a fetus. This nightmare vision is the awakening from the dream of love: the woman knows she is pregnant.

54. Shame (*Schande*), S.165, etching, engraving and aquatint
Plate: 45.5 x 31.3 cm., 17 15/16 x 12 5/16 in.
Image: 41.4 x 26.3 cm., 16 5/16 x 10⅜ in.

The pregnant woman walks alone, barefoot, her long hair shorn and her lovely clothes replaced by a coarse smock. She huddles into herself while people on the parapet above turn to stare and whisper. Beside the woman appears the ghostly figure of Slander, a psychic materialization (note that she casts no shadow) who points an accusing finger. The generally sun-bleached tonality of the print makes the solid aquatint form of the shadow all the more striking; next to this dark "second self" the figure of the woman, rendered in long, fine, parallel strokes, seems insubstantial. The effect prefigures similarly mysterious shadows in the paintings of the Italian forerunner of Surrealism, Giorgio de Chirico (see Introduction). In reading De Chirico's statement, "There is more enigma in the shadow of a man who walks in the sun than in all the religions of the world," one is reminded of this striking image of alienation from both society and self.

55. Death (*Tod*), S.156, etching, engrav-

ing and aquatint
Plate: 31.7 x 45.5 cm., 12⅜ x 17⅞ in.
Image: 22.7 x 35.1 cm., 8⅞ x 13 13/16 in.

Following a stillbirth (attempted abortion?), the dark-robed figure of Death, masked by an extravagant hat, bears away the dead child in his right arm and beckons with his left hand. The woman lies dying or dead, while the bereaved lover holds her head and weeps, his face concealed. The beautiful richness of the aquatinted bed linen is countered by the gruesomely specific details of the basin and sponge at the lower right.

ON DEATH, PART I (*Vom Tode Erster Teil*), 1889
10 plates, 4 editions: 1889, 1897, 1897, —

This cycle is concerned with the various ways in which death can come unexpectedly or accidentally to people of all stations and ages. Separate opening and closing plates bracket eight images of death, which are to be read individually. Klinger confirmed that there is no meaning to the order in which they are placed.

56. Night (*Nacht*), S.171, etching and aquatint
Plate: 31.4 x 31.7 cm., 12 3/16 x 12 7/16 in.
Image: 27.4 x 27.2 cm., 10¾ x 10 11/16 in.

In a seaside garden at night, a man (resembling Klinger) meditates, his left hand clutching his knee, the right supporting his head. By the moonlight that breaks through dense, curiously animated clouds, he contemplates a single lily plant and the moth that flutters around it. Beyond the striking design, which influenced Edvard Munch (see Introduction, Fig. 6), the print is technically rich. Aquatint is used in the grass and the man's clothes, while the background, from the sky through the sea to the near hedge, is built up in changing patterns of ever broader cross-hatching. The lily is a flower associated in Christian iconography with Easter and thus eternal life, while the moth or butterfly has traditionally symbolized the fragile ephemerality of existence. Klinger seems thus to wrestle with the question of the meaning of the inevitable end of physical life.

57. Sailors (*Seeleute*), S.172, etching and aquatint
Plate: 28.5 x 31.6 cm., 11¼ x 12 7/16 in.
Image: 25.5 x 26.4 cm., 10 1/16 x 10⅜ in.

This plate holds two images. In the larger, above, we see the results of a shipwreck, with the hull of a ship visible at the upper right. Two survivors seem to wrestle in the background, while another watches and a giant sea turtle clambers onto a rock. The threat seems double: the men will destroy themselves by fighting or be killed by the sea and its creatures. The water in the upper plate is rendered in rich aquatint, while the fiery lower plate is wholly built up in darker, rougher line. This contrasted lower plate is a vision of Hell, with a giant demon seated open-armed at the right. Before him are a crowd of naked souls, including a group of cripples who brandish their crutches at the left. Death with his scythe brings more victims.

58. Sea (*Meer*), S.173, etching and aquatint
Plate: 26.8 x 22.7 cm., 10½ x 8 15/16 in.
Image: 20.2 x 18.8 cm., 7 15/16 x 7⅜ in.

A ship founders in a stormy sea, as a ghostly skeleton reaches out over the waves to pull down the mast. Klinger's repetition of the shipwreck idea may owe to its high popularity, particularly among artists of the romantic period, as a metaphor for the disasters of tempestuous human experience. In "Sailors" Klinger tried to incorporate event and consequence by showing two separate scenes; here he manages the same combination in more subtle fashion by an innovative use of the border surrounding the strongly contrasted, active tempest of the central image. The light grey aquatint border becomes, at the bottom, a finely etched landscape: a deserted beach, on which lies, with its bottom toward us and jaw up, a solitary human skull.

59. Road (*Chaussee*), S.174, etching and aquatint
Plate: 27.7 x 17 cm., 10⅞ x 6 11/16 in.
Image: 19.8 x 13.9 cm., 7¾ x 5 7/16 in.

The scene is borrowed from an earlier landscape, Plate 28. In this version, however, the formerly threatening storm has broken and cleared; the sky is light. A woman lies in the road with a large basket beside her. The leaning stake-pole and split tree are the only evidence of the lightning bolt that has fallen, but the robed figure of skeletal Death in the right margin leaves no doubt as to its fatal impact.

60. Child (*Kind*), S.175, etching and aquatint
Plate: 27.8 x 21 cm., 10⅞ x 8¼ in.
Image: 19.8 x 10.3 cm., 7¾ x 7 3/16 in.

While a mother or nurse dozes, Death has stolen a baby from its carriage, and moves away in the distance. The print is a virtuoso display of aquatint, from the deep flat tone of the background trees that gives the sense of evening light, to the subtle light grey that traces Death's path, apparently indicating the grass that has died under his tread. In contrast to the rich variety of contrasts in the central image, the border is a roughly textured grey aquatint with details suggested in light, tremulous lines. There, two classically draped figures stand on either side, while at the bottom the sun sits on the horizon of a field. The plants add a poignant note, as the swollen seed pods bend mournfully under the weight of potential life unreleased.

61. Herod (*Herodes*), S.176, etching and aquatint
Plate: 27.7 x 19 cm., 10⅞ x 7 7/16 in.
Image: 21.4 x 14.3 cm., 8 7/16 x 5⅝ in.

A throne, with decorative lions forming its sides and arms, stands on a stepped pedestal in the middle of a large amphitheater. The king has been stricken; clutching himself, he has fallen to the ground, with his cape still snagged in the mouth of one of the lions. A large shadow is cast across the arena as the setting sun just gilds the top corner of the throne. Numerous spectators observe the agony from afar, while in the left margin a lone soldier idly extends his foot to play with the crown, seen rolling away at the bottom center. As in a medieval Dance of Death, Klinger stresses the concept that earthly station provides no protection against the whim of death.

62. Farmer (*Landmann*), S.177, etching and aquatint
Plate: 18.7 x 29.7 cm., 7 5/16 x 11 11/16 in.
Image: 14.7 x 26.7 cm., 5¾ x 10½ in.

The farmer has been replowing a furrow that leads directly into the image at the lower right, then bends sharply to the left. The horse nearest to us has his rear foot tangled in the chain of the plow. In an attempt to free this foot, the farmer has been accidentally, and fatally, kicked in the face. He lies face down in the furrow, as his blood spills through his fingers into the earth. On the left and right, the margin shows the tall grain the farmer had hoped to grow, but in the lower margin, Klinger presents the macabre fantasy of a view under the earth. Buried there, a bloated figure lies with his head and feet propped up, as on a monumental tomb; his footrest is a skull, his pillow a

swollen dead animal (dog?). Other borders in this cycle also play, in relation to their central images, the roles of symbolic comment or vision of the future. Here, in a horrifyingly literal merging of the two worlds, the underground corpse reaches up to drink in greedily the farmer's life blood. Butterflies flutter above, while the horses stand by passively, and a dark shadow steals over the landscape.

63. On the Tracks (*Auf den Schienen*), S.178, etching and aquatint
Plate: 26.3 x 18.8 cm., 10⅜ x 7⅜ in.
Image: 21.7 x 14.5 cm., 8½ x 5 11/16 in.

Railroad tracks curve through a precipitous mountain landscape. Across the tracks reclines a chillingly casual skeleton, who crosses his legs and whistles for the train to come. The aquatinted and heavily hatched border is the dark night to come after this ironically sunny day. This border contains one of Klinger's most macabre inventions: a twisting plant-like motif that consists of a bloated serpent intertwined with a twisted section of track. On the lower left, this plant blooms: the serpent breathes fire, and ghostly heads, symbolizing the dead passengers, rise like puffs of smoke to fill the rest of the border with varying expressions of anguish.

64. Poor Family (*Arme Familie*), S.179, etching and aquatint
Plate: 27.7 x 19.5 cm., 10⅞ x 7 11/16 in.
Image: 21.7 x 14.3 cm., 8 9/16 x 5 11/16 in.

From a garret window, a poor mother stands staring out, head in hand, as her child embraces her neck. In the right background sits an old man, probably the father or grandfather. Klinger signifies death by a pattern of radiating lines that create an aura around the old man's head. More explicitly, the skeletal figure of Death stands in the left margin, holding an opened hand against the edge of the central image. In the margin below, and continuing on the right, we see a nocturnal landscape, with a man digging two graves in an open field. Here, in contrast to the other scenes, death seems to come naturally, at the end of a difficult life.

65. Death as Savior (*Der Tod als Heiland*), S.180, etching and aquatint
Plate: 24.2 x 31.2 cm., 9½ x 12 5/16 in.
Image: 22.4 x 29.9 cm., 8 13/16 x 11¾ in.

This is one of Klinger's most complex and enigmatic visual statements. The format, that of a picture within an elaborate frame, recalls the figural frames that the artist carved for his own paintings. The central image shows Death appearing in a barren landscape. On the right, a terrified group of people in classical dress flee, while one figure, apparently in contemporary dress, remains in a posture of worship. Around this bright, severely composed scene, a frantic, demoniacal pursuit takes place in the margins. At the lower right and left corners, two grisly hearts sprout tendrils that loop and curl outward to become thorny branches, perches for the crows and owl at the upper left. Along the right edge, one demon accosts a standing figure strongly reminiscent of Michelangelo's *Dying Slave*, while another demon (upper right corner) drags a body by the neck as he pursues a fleeing nude woman, to whom he beckons with an insidious finger. The most incredible fantasies, however, are in the lower margin: at the right, a woman resists the grasp of a giant beast, part human, part toad, while on the left, a woman is raped by a giant lobster. The figure of the dead man below recalls figures of the dead Christ by Holbein and Grünewald, and its inclusion makes the image as a whole resemble a Renaissance or late medieval wall tomb. The meaning of all this, and the final message of this cycle, is given in the inscription, just above the reclining dead man: "Wir flieh'n die Form des Todes, nicht den Tod; denn unsrer hoechsten Wuensche Ziel ist: Tod" (We flee from the manner of death, not from death itself; for the goal of our highest desires is death). Death itself, for the peace it brings, is not fearful, but we are terrified by its many ways of coming unexpectedly to us. The inscription apparently derives from a passage in Moses Mendelssohn's *Phädon*.

BRAHMS FANTASIES (*Brahmsphantasie*), 1894
41 plates, 2 editions (both 1894)

This cycle was conceived as an accompaniment to a group of songs and a choral work composed by Johannes Brahms. The music is printed in the folio, and Klinger's images, including numerous smaller decorative vignettes as well as fully conceived scenes, are interspersed throughout. The prints are not illustrations in the strictest sense of the word; rather, they are images inspired by, and intended to evoke the feeling of, the music. The songs and choral work themselves were settings of poems by a number of German poets, Julius Almers, Karl Candidus, Paul Heyse and Friedrich Hölderlin (the prints to accompany the poem of Friedrich Halm were never com-

pleted). The ambition thus manifest here, to join the expressive powers of literary, musical and visual arts, appeared frequently in advanced art theory in the late nineteenth and early twentieth centuries. The fantasies were also a personal tribute, since friendship as well as mutual admiration linked Klinger and Brahms. The composer greatly appreciated this homage, and in 1896 he dedicated a suite of songs to Klinger. Of all the cycles, the *Brahms Fantasies* display the broadest range of media and technique, lithograph and mezzotint as well as etching and engraving. The series is divided into two halves, each preceded by a prelude image. The first half contains four songs for solo voice and piano, accompanied by five etchings and twelve lithographs. The second half opens with six large plates depicting episodes from the legend of Prometheus, the demigod who brought fire to earth. These are followed by four engravings and eleven lithographs connected with the choral and orchestral setting of Hölderlin's *Schicksalslied* (Song of Fate). After the *Schicksalslied,* the second half closes with a final image of Prometheus, freed from the torture to which Zeus had subjected him.

66. The Cold Hand (*Die kalte Hand*), S.193, engraving and etching
Plate: 17.8 x 13.2 cm., 6 15/16 x 5 1/8 in.
Image: 16.3 x 11.9 cm., 6 7/16 x 4 5/8 in.

In a moonlit field, a man sits alone, leaning his head on, and pressing both his hands against, a tree at the left. From above materialize the ghostly hand and arm of a woman, reaching down to touch his chest. Designed to accompany the music written for a Bohemian folksong, the image is that of the memory of a departed lover coming to a man in his yearning, to touch his heart like a cold hand.

67. Evocation, S.201, etching, engraving, aquatint and mezzotint
Plate: 29.4 x 35.6 cm., 11 9/16 x 14 in.
Image: 22 x 33.8 cm., 8 5/8 x 13 1/4 in.

The prelude to the second half of the cycle, this print is technically one of Klinger's most varied plates. Across the sky, lightly etched Titans rage in a furious assault. In the foreground, softly focused but tonally and texturally rich mezzotinted figures stand before a crisply aquatinted balustrade,

with a sharply engraved rolling sea behind. As the man on the left plays the piano, a woman appears before an ornate harp on the right, letting fall her drapes and mask. According to Singer, she personifies the forces of nature.

68. Night (*Nacht*), S.203, etching and aquatint
Plate: 27.4 x 38.8 cm., 10 3/4 x 15 1/4 in.
Image: 24.4 x 35.8 cm., 9 9/16 x 14 1/8 in.

This is the second plate in the story of Prometheus. At the upper left, the young Prometheus sits listening to Pallas Athena. In mythological tradition, Athena instructed Prometheus in all the practical arts and sciences—medicine, architecture, etc.—that he eventually passed along to mankind. Across the rest of the plate extend the earth and its seas, bound in darkness by Zeus's refusal to give fire to mankind. From the darkness in the distance, giant images of suffering emerge: an agonized face, prostrate bodies and an upstretched arm. The vast night sky is punctuated by the stunning whiteness of three birds.

69. Theft of Light (*Raub des Lichtes*), S.204, etching and mezzotint
Plate: 29.3 x 35.9 cm., 11 9/16 x 14 1/8 in.
Image: 25 x 33.3 cm., 9 13/16 x 13 1/8 in.

Aided by Athena, Prometheus was able to enter the Olympian regions undetected. There he lit a torch from the chariot of the sun, and carried it away to deliver fire to mankind against the wishes of Zeus. Here, Prometheus swoops through the inky sky, holding aloft the torch that leaves a trail of light to mark his path from the heavens. As he descends, the light reveals the crowded mass of humanity that rushes desperately toward him. The soft, dim light and the velvety darkness are the result of heavy use of mezzotint.

70. Abduction of Prometheus (*Entführung des Prometheus*), S.206, etching, engraving and aquatint
Plate: 27.8 x 38.2 cm., 11 x 15 1/8 in.
Image: 24.1 x 36.4 cm., 9 7/16 x 14 5/16 in.

Zeus has ordered that Prometheus be punished for his deed. He is to be chained to a mountain rock, where an eagle will eat his liver every day (the torture continues because each night the liver grows back). Here, he is carried away by Hermes (Mercury), who holds his knees, and by the eagle of Zeus, who clutches his arms. Below, a deserted seacoast stretches before a distant

snow-covered mountain. The vast background is evoked in long parallel striations, while the bodies are described in a wholly different system of fine, short modeling strokes. Because of this, and because of Klinger's careful use of points of sharp tonal contrast, the tense physical effort of the abduction stands out with a disjunctive, hallucinatory clarity.

ON DEATH, PART II (*Vom Tode Zweiter Teil*), 1898–1909
12 plates, 2 editions

Klinger worked longer on this cycle than on any other. Some of the individual plates in the group date back as far as 1879. The relation of the cycle to *On Death, Part I* is not completely clear. According to Singer, the two should be considered as two parts of one integral conception, but others stress the differences in conception that separate them. In *On Death, Part I*, the plates deal with unconnected instances of the physical fact of unredeemed and usually unexpected death. In *On Death, Part II*, by contrast, each instance is chosen for its symbolic illustration of a larger principle. The cycle has a programmatic plan of meaning, dealing with death in its spiritual or metaphysical consequences rather than in its physical manifestations. In further contrast to *On Death, Part I*, this cycle ends on a quasi-religious note of philosophical optimism that counterbalances the physical horror of death. The first two parts of the cycle are concerned with images of mass death on the one hand (plague, war and forced labor), and with selected instances of death at the highest levels of society (the ruler, the genius and the philosopher) on the other. After a transitional plate entitled "And Yet . . ." (Und doch), Klinger then presents four final plates that embody, without reference to any religion or conception of an afterlife, a consoling idea of continuity beyond death. These last plates assert that nature's fertility will survive the destruction of man's achievements, and that the ongoing survival of humanity will compensate for the death of individuals. The final image exhorts the reader to worship beauty as the only consoling, enduring value.

71. Blameless in Life . . . (*Integer vitae . . .*), S.230, engraving
Plate: 40.6 x 31.7 cm., 16 x 12½

in.
Image: 39.2 x 30 cm., 15 7/16 x 11¾ in.

This, the opening plate of the cycle, is a complex allegory that, according to the dates inscribed at the lower left, Klinger held in process from 1885 to 1900. In the foreground a nude youth walks forward with arms extended, toward a cliff. According to Singer, he represents humanity groping in darkness, recoiling from the abyss. Behind him we see, in a landscape of blasted trees, the ruins of the civilizations of Greece and Rome. Above all this rises a vision of clouds and mountains on which sits the giant figure of Time. With his right hand he closes off the top of a volcano, while with his left he holds an hourglass. Under the hourglass, on the edge of the abyss, are figures representing the religious leaders of the past, Moses, Christ and Buddha, and the Greek god Zeus. The Latin inscription from Horace at the lower left, "Integer vitae, scelerisque purus," means "Blameless in life, free of evil."

72. Philosopher (*Philosoph*), S.232, etching and aquatint
Plate: 49.5 x 33.6 cm., 19½ x 3¼ in.
Image: 49.5 x 33.6 cm., 19½ x 3¼ in.

Klinger executed two entirely different plates entitled "Philosoph," a preliminary one that was never published with the cycle, and this, a second version. This representation of the philosopher joins those of the ruler and genius in Klinger's conception of those at the highest levels of society whose formidable powers and intellectual achievements still do not enable them to fully understand, let alone stave off, inevitable death. Klinger attempts to convey the intellectual's striving for understanding in this meditative image of self-confrontation.

73. Plague (*Pest*), S.234, etching and aquatint
Plate: 43.6 x 33.5 cm., 16 15/16 x 13 3/16 in.
Image: 36.3 x 31.2 cm., 14 5/16 x 12¼ in.

The scene is a hospital ward, jammed with beds in which people lie dying. A blast of wind has opened the window, admitting a flock of crows. Two of the birds sit with sinister patience at the end of a bed in the background, while two others seem to attack the dying man in the foreground. They, and the death by plague they symbolize, are combated by a nun who swings a rosary in defense. In the background, two other patients kneel to pray before a large cross near the wall. The image stresses the inefficacy

of religion in the face of death.

74. Dead Mother (*Tote Mutter*), S.239, engraving
Plate: 45.6 x 34.8 cm., 17 15/16 x 13 11/16 in.
Image: 39.2 x 30 cm., 15 7/16 x 11¾ in.

In the foreground is a bier, on which a young woman lies dead, flowers entwined in her hair and a tall candle burning by her head. On her chest sits an infant, which turns its head to look out at us. Immediately behind the bier is an arched doorway, flanked by elaborate twisted columns, giving onto nature. (According to Singer, Klinger based this architecture on designs studied in Rome, at St. Paul's Outside the Walls). Through dark trees, the sea appears in the distance. The image conveys the consoling message that, though the individual dies, the human race continues. The idea of ongoing fertility is conveyed not only by the infant itself, but also by the young tree that is illuminated in the background—a combination of symbols that recalls early nineteenth-century German romanticism (especially paintings by Philipp Otto Runge). An inscribed date attests that Klinger conceived this plate in 1889.

POSTSCRIPT

Two of Klinger's graphic cycles are not illustrated here: (1) *Festschrift des Kgl. Kunstgewerbe-Museums zu Berlin*, 1881 (14 plates), a series of decorative plates for a publication celebrating the new Decorative Arts Museum in Berlin; Klinger did not assign this group of etchings a number within the sequence of his cycles, and Singer relates that the artist considered it a "potboiling" commissioned task rather than a creative enterprise. (2) *Das Zelt,* 1915 (46 plates), a bizarre Oriental fairy tale of Klinger's invention, relating the abduction of a princess, the story of the knight who frees her and various (exceedingly bloody) incidents along the way. This latter cycle was not included in Singer's catalogue, which was completed before its appearance. Both in technique and in composition of the images, it is difficult not to see *Das Zelt* as symptomatic of a decline in the artist's powers.

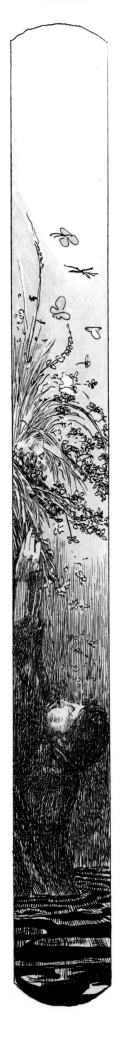

Technical Note

by Elizabeth Sahling

J. Clawson Mills Fellow, Metropolitan Museum of Art

In Klinger's early cycles etching is the predominant medium. He apparently gained his first experience with the technique at the suggestion of Hermann Sagert, an engraver and art dealer who knew his drawings, and he took to it easily. The manipulation of an etching needle is related to the handling of a pen in that lines can be drawn freely and spontaneously. Klinger at the age of 21 was already an accomplished draftsman, and this skill was readily transferred to the copper plate.

An etching is made by coating a metal plate, usually copper, with an acid-resistant ground, of which wax is the principal ingredient. The design is drawn with a needle through the ground, exposing the metal beneath. The plate is then immersed in an acid bath; the chemical action of the acid erodes or bites away the metal in the areas that are unprotected by the ground, that is, in the lines drawn by the artist. The depth and width of these lines depend on the length of time the plate remains in the acid. When a line has been sufficiently etched, it can be protected by a coat of ground from further corrosive action; this is called stopping out. Then the plate can be returned to the acid to strengthen lines selectively.

In etching the reproduction of line is of primary importance. The aquatint method, in contrast, produces even tones. But both processes are dependent for effect on the action of acid on a

Border illustration (lithograph; S.197) from *Brahms Fantasies*.

metal plate, and are frequently found in combination on the same plate. To achieve a tint or a wash instead of a line, an area of the plate is covered with an asphalt or rosin grain, which can vary in texture from coarse to very fine. These particles of rosin are dusted onto the plate and then the plate is heated until they adhere. Those parts of the plate which will print white are stopped out. When the plate is submerged the acid bites around and among the grains, and the longer the plate remains in the acid, the darker these pitted areas will print. If the acid has bitten deeply enough, the tint will print black. Various tonal effects can be obtained by interrupting the biting process and stopping out the areas which will already print dark enough. Additional tonal variety is produced by burnishing and scraping the surface of the plate after the acid bath. The pitted surface is scraped away so that an area will hold less ink and will therefore print a lighter tone. The result of burnishing an aquatint plate is not unlike that of erasing lead pencil.

Klinger was undoubtedly influenced in his use of the aquatint medium by Goya's prints. "Into the Gutter!" (Plate 33) from *A Life* clearly demonstrates a technical as well as thematic and stylistic debt to Goya's *Caprichos*. The contrasting tones of aquatint provide the dramatic focus on the tormented woman. The highlights in her dress were produced in three successive bitings, the brightest areas being stopped out first. But the range of these pale tones is still narrow, and the dark mass of the old women and grotesque monk provide a strong foil, while etched flecks reinforce the grainy quality of the background. The woman's features are delineated with the etching needle, and the eyes and mouth received a second biting: under magnification the single lines can be seen to widen and blacken.

"Death" (Plate 55) from *A Love* demonstrates Klinger's virtuoso command of the aquatint medium. Multiple bitings, probably seven or eight, have produced an extensive tonal range from palest grey to deepest black. In addition, burnishing elicits a more shadowy soft-edged gradation of tones on Death's sleeve. The aquatint varies not only in tone but also in texture, owing to gradations in the size of the rosin grain. The grain was selectively controlled as it was dusted onto the plate; the heaviest and largest

of the grains were deposited above Death's head, leaving distinct white dots, like a sprinkling of stars. This area illustrates on an enlarged scale the sparkling effect aquatint can have. A much finer grain was used on the bed linen in the foreground, giving it a satiny luminescence. The ragged edges of the strokes of stop-out varnish on the bed linen emphasize the anguish and horror of this scene of death.

The sober tones of etching and aquatint are displayed to great effect in "The Road" (Plate 28). A graded tint, like that of the lowering sky, is produced by tilting the plate in the acid bath. Only that part of the plate where the tint should be strongest is held consistently submerged in the acid, and the plate is rocked so that the acid intermittently comes up over the rest of the plate. Alternatively, to produce this kind of gradation, a piece of blotting paper may be laid over the plate, with only one end in the acid. The paper gradually draws up the acid over the entire surface, and the plate is thus exposed to the acid's attack for a longer time at one end, the period of exposure diminishing gradually toward the other end.

The pebbly surface of the road, with its puddles and uneven surface, was created by etched dots and a very coarse-grained aquatint which was partially bitten off in the center of the road to give the effect of a wet reflecting surface. These light areas of reflecting water are also found around the first tree and in a stream flowing into the grass at the side of the road. This bright reflection provides a disturbing contrast to the dark foreboding sky.

The etching in "The Road" is also varied considerably for expressive purposes. The finest work is found at the end of the road nearest the horizon, where clouds or trees were stopped out when the aquatint was applied. Multiple bitings were necessary to achieve the gradation between this delicate shading, the medium tone of the leaves and grass, and the very deep black lines of the vine and tree in the foreground. The distinct tonal character of the lines at each step on this graduated scale can only be achieved by careful timing of each successive biting.

Klinger also worked directly on the plate with a number of tools—the drypoint needle, the roulette, and the graver. For the

most part, these tools were used to touch up or finish prints that were executed primarily in etching or aquatint. The manual work generally would have been subsequent to the final biting.

A drypoint needle has a sharp point which tears the surface of the plate as it is pulled through it. The rough filings of metal displaced by the point rise up on either side of the furrow made in the metal by the moving needle and are called burr. The extra ink that is held by these filings prints as a velvety bloom on either side of the line. This effect can be seen clearly on the folds of drapery on the foreground etched figure in "Suffer!" (Plate 36). The extremely fine lines frequently used by Klinger to model flesh are also produced by the drypoint needle (the burr is usually scraped away from these drypoint touches).

The roulette, a spiked wheel on a handle, marks the plate in a series of tiny dots, and also produces burr which holds ink and prints in a blurred fashion. Roulette work can be seen in "Death" (Plate 55) along the contour of the woman's left leg and on the drapery over the pelvic area. The smudged effect in this area has its own gruesome impact here.

The graver or burin used in engraving cuts a V-shaped groove in the surface of the plate. The ink is held in the troughs left in the plate by the graver. By manipulating the angle of the graver as it cuts, the artist can produce tapering and swelling in a single line.

The *Brahms Fantasies* (Plates 66–70) is technically the most complex and varied of Klinger's cycles, including both mezzotint and lithography, as well as etching, engraving and aquatint. Twenty-three lithographs appear as decorative panels accompanying the musical notation. These vignettes are litho pen drawings (pen drawings done with greasy lithographic ink on transfer paper or directly on the lithographic stone), some of which are printed in two or more colors.

To make a lithograph, an image is drawn with a greasy substance on (or transferred to) a smooth polished block of limestone. The stone is washed with water, which is repelled by the greasy portions. When ink is rolled over the stone, it adheres only to the greasy drawing. The artist himself need only be concerned with the rendering of the drawing; the actual preparation of the

stone and the printing are generally the task of a professional printer. Lithography appears in Klinger's work only in conjunction with sheet music, and was probably called for by practical printing considerations. The medium was not exploited by Klinger at any other time to produce independent works of art.

For mezzotint, a process that plays a substantial role in the *Brahms Fantasies*, a metal plate is prepared to print a uniform black. This black tone is produced by roughening the plate surface with a rocker (a serrated instrument with a half-round cutting edge) or a roulette to obtain an even burr over the entire surface. A scraper or burnisher then reduces or removes the burr in certain areas to create the design in lighter tints.

This technique, which produces a velvety finish with rich halftones and highlights, was used with brilliant effect in "Theft of Light" (Plate 69). The earthbound figures barely begin to emerge as Prometheus transports his torch through the sky. The thick opacity of the medium is ideal for the evocation of primeval darkness. With mezzotint it is impossible to achieve a sharp edge, but this limitation is turned to advantage here as the torch's trail of smoky brilliance brings up dusky highlights of the nearby nude bodies. The pattern of the rocker's edge is still visible in the burnished areas.

"Evocation" (Plate 67) represents the widest range of copperplate techniques employed by Klinger in a single print, and demonstrates as well the way in which he contradicted accepted conventional use of these media. There is a sharp division between the tonal and the linear, marked by the aquatint balustrade. From the balustrade forward, the forms are created by tonal masses. The foreground figures here exist as strange dark clouds of mezzotint against a light background, though a design in mezzotint usually works in the opposite way, from dark to light, with the focus of a composition appearing as a highlighted object emerging from a black background. The matte grey tone of the aquatint on the balustrade, with its hard edges outlined by etched lines, provides an additional jarring note, relating to no other part of the tonal scale of the composition. Behind the balustrade lies only linear construction. The dark engraved lines of the water contrast with the fine unmodulated etched work delineating the Titans and

centaurs in the sky.

Klinger was extremely adept at manipulating a broad range of graphic processes and exploiting their expressive possibilities. However, in their service to his artistic intentions, these techniques were pressed into bizarre combinations and idiosyncratic juxtapositions with curious and disquieting effect. Perhaps his ingenious technical virtuosity and bravura dissipate the focus in his later cycles, and an early work like *A Glove* (Plate 18–27), one of the least complex technically, remains, in its restraint, his strongest.

Bibliography

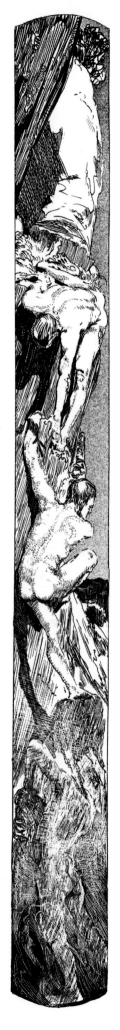

ADLMANN, JAN. "Rediscovering Max Klinger," *Art News,* vol. 70, no. 9 (January 1972), pp. 52 ff.

ASHBERY, JOHN. "The Joys and Enigmas of a Strange Hour," *Art News Annual,* 1967.

AVENARIUS, FERDINAND. *Max Klinger als Poet.* Munich: G. D. W. Callwey, 1921.

BEATTY, FRANCES. "Max Klinger—The Premonition of Illusion," *Art in America,* vol. 62, no. 4 (July–August 1974), pp. 78 ff.

BEYER, CARL. *Max Klingers Graphisches Werk von 1909 bis 1919—Eine Vorläufige Zusammenstellung in Anschluss an den Oeuvre-Katalog von Hans W. Singer.* Leipzig: P. H. Beyer und Sohn, 1930.

DE CHIRICO, GIORGIO. "Max Klinger," in *Metaphysical Art,* compiled by Massimo Carra with Patrick Waldberg and Ewald Rathke. Translation and historical foreword by Caroline Tisdall. New York: Praeger, 1971, pp. 97 ff. (First published in *II Convegno,* Milan, May 1920.)

DÜCKERS, ALEXANDER. *Max Klinger.* Berlin: Rembrandt Verlag, 1976.

HOFSTÄTTER, HANS H. *Idealismus und Symbolismus.* Vienna & Munich: Anton Schroll und Co., 1972.

HOFSTÄTTER, HANS H. *Symbolismus und die Kunst der Jahrhundertwende.* Cologne: M. DuMont Schauberg, 1965.

KLINGER, MAX. *Malerei und Zeichnung,* 2nd ed. Leipzig: Breitkopf & Härtel, 1895.

KÜHN, PAUL. *Max Klinger.* Leipzig: Breitkopf & Härtel, 1907.

MAX KLINGER 1857–1920. Ausstellung zum 50. Todestag des Künstlers, 4 Juli – 20 September 1970. Leipzig: Museum der bildenden Künste.

MAX KLINGER: *A Glove and Other Images of Reverie and Apprehension.* Wichita, Kansas: Wichita Art Museum, 1971.

PASTOR, WILLY. *Max Klinger.* Berlin: Amsler, 1919.

SCHMID, MAX. *Klinger.* Bielefeld: Velhagen, 1906.

SINGER, HANS W., ed. *Briefe von Max Klinger aus den Jahren 1874 bis 1919.* Leipzig: E. A. Seemann, 1924.

SINGER, HANS W. *Max Klingers Radierungen Stiche und Steindrucke.* Berlin: Amsler und Ruthardt, 1909.

Border illustration (lithograph; S.215) from *Brahms Fantasies.*